GARDENS IN BLOOM

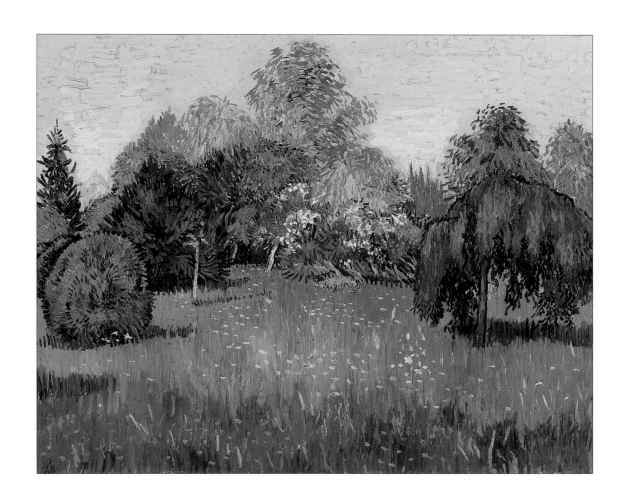

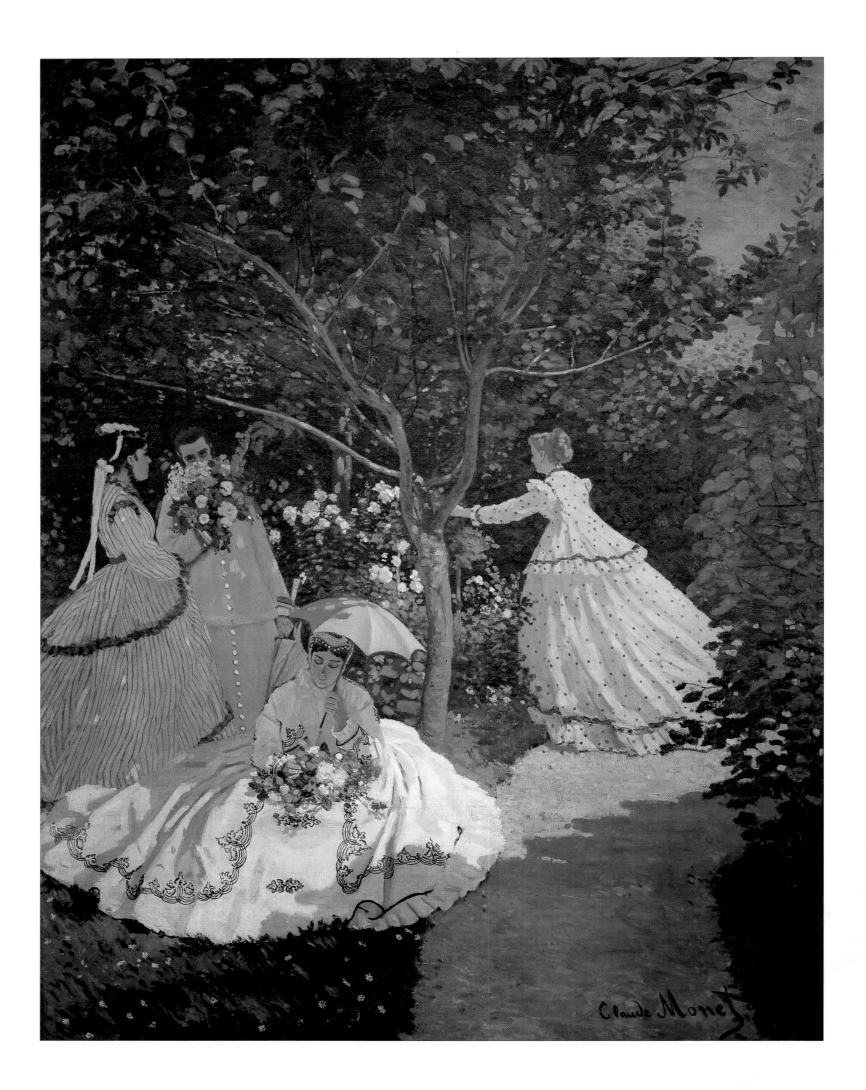

CELEBRATIONS IN ART

GARDENS IN BLOOM

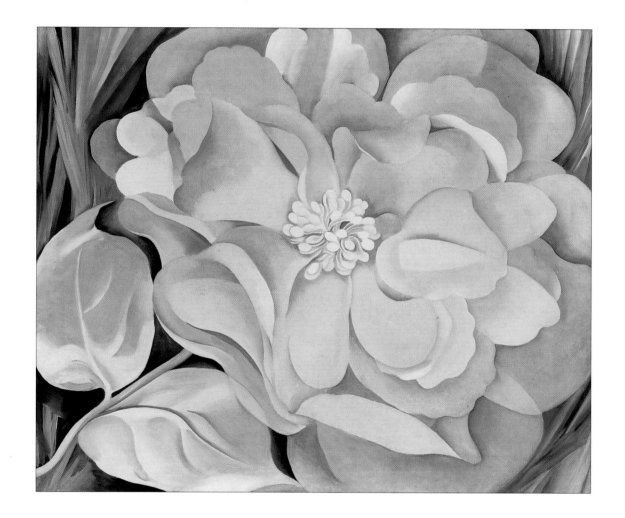

ROXANA MARCOCI

MetroBooks

MetroBooks

AN IMPRINT OF FRIEDMAN/FAIRFAX PUBLISHERS

©1995 by Michael Friedman Publishing Group, Inc.

Library of Congress Cataloging-in-Publication Data

Marcoci, Roxana.
 Gardens in Bloom/Roxana Marcoci.
 p. cm. — (Celebrations in art)
 Includes bibliographical references.
 ISBN 1-56799-163-7
 1. Gardens in art. 2. Flowers in Art. 3. Painting, Modern—19th century. 4. Painting, Modern—20th century. I. Title. II. Series.
ND1460.G37M37 1995
758'.1—dc20 94-32480
 CIP

Editor: Sharyn Rosart
Production Editor: Loretta Mowat
Art Director: Jeff Batzli
Designers: Lynne Yeamans & Lori Thorn
Photography Editor: Wendy Missan

Color separations by Bright Arts (Singapore) Pte. Ltd.
Printed in China by Leefung-Asco Printers Ltd.

For bulk purchases and special sales, please contact:
Friedman/Fairfax Publishers
Attention: Sales Department
15 West 26th Street
New York, NY 10010
212/685-6610 FAX 212/685-1307

Additional Photography Credits: page 1: Vincent van Gogh, *The Garden of the Poets*, 1888. Oil on canvas, $28\frac{3}{4}$" × $36\frac{1}{4}$" (73 × 92.1cm). The Art Institute of Chicago. Page 2: Claude Monet, *Women in the Garden*, 1866. Oil on canvas, $100\frac{1}{2}$" × $80\frac{3}{4}$" (255.3 × 205.1cm). Musée d'Orsay, Paris, Erich Lessing/Art Resource, NY. Page 3: Georgia O'Keeffe, *The White Calico Flower*, 1931. Oil on canvas, 30" × 36" (76.2 × 91.4cm). Whitney Museum of American Art, New York. Page 5: Childe Hassam, *Celia Thaxter in Her Garden*, 1892, oil on canvas, $22\frac{1}{8}$" × $18\frac{1}{8}$" (56.1 × 46cm), National Museum of American Art, Smithsonian Institution, Washington, D.C./Art Resource, NY

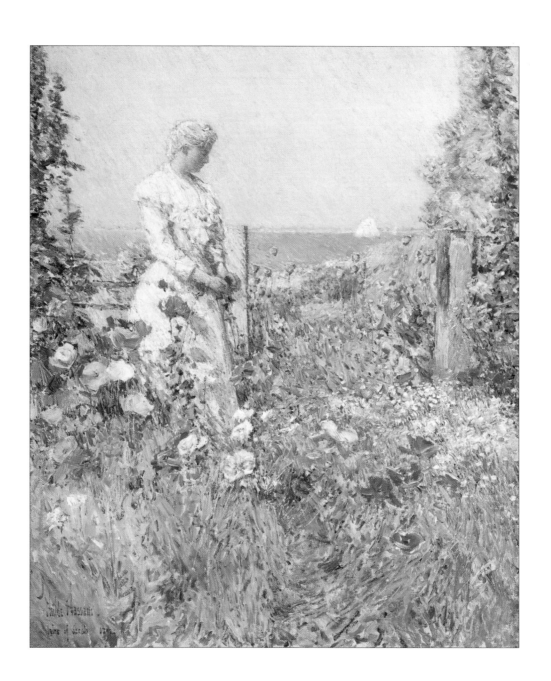

INTRODUCTION

The blooming garden, the embodiment of life and growth, full of lush greenery and colorful flowers, has always held a special place in the human heart. Indeed, in many cultures, the idea of paradise, envisioned as a place filled with lush greenery and enticing vegetation, corresponded to the garden. It is hardly surprising, then, that artists have long been inspired by gardens to create some of the most enduring works in the history of painting.

In the Western world, ever since the Middle Ages, Christian images of paradise had taken the form of flowery meads, while allegories and mythological works had used the garden in its myriad manifestations as backdrop for their narratives. Such is the case with Hugo van der Goes' *The Fall, Adam and Eve Tempted by the Snake* (c. 1470), Sandro Botticelli's *Primavera* (c. 1482), and Hieronymus Bosch's triptych *Garden of Delights* (c. 1505–1510), which articulate the garden as a site for mystical experiences. Bosch's *Garden of Delights* brackets scenes of paradise and hell around a central panel that presents a garden of worldly pleasures. The whole is set in a landscape whose idiosyncratic vegetation and variety of colors would later appeal to those provocateurs of the unconscious, the Surrealists.

As the Renaissance gave way to the Age of Reason, changes in the image of paradise evolved through geographical exploration, philosophical developments, and scientific advances. Indeed, by the eighteenth century, the ideal garden had become an almost completely secular vision.

In the mid-eighteenth century, the philosopher Jean-Jacques Rousseau, expressing the preoccupations of his era with the moral repercussions of progress, redefined the garden as a cultivated wilderness in which people could find seclusion for reflection. At about the same time, artists began projecting a different mood onto nature, at once nostalgic and romantic in spirit. Hubert Robert, a disciple of Giovanni Battista Piranesi and GianPaolo Pannini, portrayed gardens within the tradition of imaginary and fantastic ruins in landscape painting. Following a trip to Rome, Robert specialized in the genre of picturesque gardens, a practice that won him the nickname "Robert of the Ruins." The public's taste for ruins had been prompted by the unearthing in 1748 of the Roman city of Pompeii.

In France, the pleasure-garden paintings of the eighteenth-century artists Antoine Watteau, François Boucher, and Jean-Honoré Fragonard captured the decadent elegance of aristocratic society in its final flowering before the French Revolution. For theatrical fantasy, romantic pursuits, and idyllic pastimes, nothing has since surpassed that golden era of

fêtes galantes. Works like Watteau's *Assembly in a Park* (c. 1647) or Fragonard's *The Island of Love* (c. 1775) are representations of the garden as an ideal playground designed for a society that enjoyed festive games. Often the scenes of nature and love are touched by melancholy, as the age of pleasure was expiring under the reforming attitudes of the scientifically minded Encyclopedists and the neoclassical spirit of the French Revolution.

Although landscape painting was considered a minor genre in European art during the eighteenth century, the names of two major British painters, John Constable and J.M.W. Turner, stand out. Constable's aim was to raise the study of natural phenomena above the level of reportage. Turner's contribution lay in the reconciliation of divergent scenic traditions, that is, he combined the descriptive naturalism of the Dutch with the elegiac pastoralism of the Italian painters previously championed by the two French expatriates Claude Lorrain and Nicolas Poussin.

The main figures of the Pre-Raphaelite gardenscape are William Holman Hunt, Sir John Everett Millais, and Ford Madox Brown, whose detailed recordings of the minutiae of nature point to the writings of their mentor, the art critic John Ruskin. Ruskin's interest in botany and geology led the painters to concentrate on achieving naturalism through laborious execution of the scenery. Thus, the technical originality of the Pre-Raphaelites resides in their complete fidelity to the landscape—which was observed out-of-doors in natural daylight—and in their use of bright colors applied on a wet white ground with a minimum of shadows. This procedure ensured a high degree of clarity and luminosity that defied the enforced conventions of the Royal Academy. The Pre-Raphaelites' reverence for nature was moralistic in content, hence the group's interest in the art of the Nazarenes, an association of German artists who had lived in Rome since 1810 and specialized in monastic themes. Because the Pre-Raphaelites' idea of modernity was based on medieval and literary themes, their views of the garden conveyed a large number of issues, some related to Christian symbolism.

As we have seen, painters of every age and persuasion have portrayed gardens; however, today the subject tends to be exclusively identified with nineteenth-century French Impressionist and Postimpressionist currents. Known as the age of garden culture, this period was marked by the urban campaigns of Parisian garden lovers such as Baron Haussmann (1809–1891), who helped to transform Paris into a city of grand boulevards, open squares, and public parks laid out on the English model. These *jardins anglais* differed in concept from the early nineteenth-century British parks, which were designed according to the strict puritanism of the Victorian ethos and thus were much more formal and restrained. The lively spirit of the French gardens can be found in such paintings as Edouard Manet's *Music in the Tuileries* (1862), Claude Monet's *La Grenouillère* (1869), and Pierre-Auguste Renoir's *Le Moulin de la Galette* (1876).

Like many artists before them, the Impressionists looked at their surroundings—in particular, the city's public gardens and suburban green spaces—not just for light, fresh air, and atmospheric effects, but also in terms of social exchanges. The opening up and landscaping of Paris undoubtedly brought a new sense of mobility and visibility and of public life. Thus, parks and gardens became ready-made sites for the artist to absorb and depict both nature and how people used their leisure time. Monet's *Women in the Garden* (1866), for instance, is a work which has as much to do with flowers and the arrangement of nature into harmonized form as it does with the new codes of modernity, feminine grace, and fashionability. By emphasizing the mood of elegant hedonism characteristic of the Second Empire, Monet provides us not only with an exquisite depiction of a garden but also with some insight into the social habits of his era.

In the late 1880s, Mary Cassatt, John Singer Sargent, Childe Hassam, and William Merritt Chase developed the American wing of Impressionist painting. Although many Americans had studied at the Academie Julian in Paris, and therefore were familiar with the works of French contemporary artists, the most important factor in introducing French Impressionism to the States was the 1886 decision of art dealer Paul Durand-Ruel to organize a large exhibition in New York of the art of Manet, Monet, and Renoir and subsequently to open a gallery in New York to represent the works of Monet, Sisley, and Pissarro.

American Impressionism was a hybrid of avant-garde and academic traditions. In terms of theme, the motif of gardens preoccupied both Chase and Cassatt. In *The Open Air Breakfast* (c. 1888), set in his own backyard, Chase resumed a theme that had been popular among his French colleagues. Monet's *The Luncheon* (1873), set in his garden at Argenteuil, which is portrayed as a suburban arcadia, may have functioned as a prototype. After the destruction wrought by the Franco-Prussian War and the Commune of Paris, when parks such as the Bois de Boulogne were ruined, well-to-do Parisians often bought country houses with gardens that would function as retreats from the urban world. Thus, the garden became the topic not only of the avant-garde, but also of more academic artists such as James Tissot and Frederic Bazille, and the latter recorded it as a private place for himself and his family.

In the United States the garden was also a subject for the exotic visions of the nineteenth-century Hudson River landscape painters. Frederic Edwin Church, Fitz Hugh Lane, and Martin Johnson Heade portrayed the wilderness of such locales as Lake George, the Adirondack Mountains, the Maine coast, the Catskills, Niagara Falls, and many other vistas, which were rational in their detailed "Ruskinian" style, yet poignant and romantic in their luminist effects, sense of escapism, and panoramic scale.

Although they dealt with the American land, the Hudson River landscape painters also felt some foreign influences, which ranged from French classical landscape painting to seventeenth-century Dutch realist scenery. Furthermore, under the influence of William Morris Hunt, American patrons of the arts began acquiring French works by painters of the Barbizon school, and later by Impressionist artists. Hunt was instrumental in developing a taste for Barbizon landscape painting, particularly among Boston collectors. Works by Jean-Baptiste-Camille Corot, Théodore Rousseau, Charles-François Daubigny, and Johan Barthold Jongkind quickly became popular in American collections. These artists' evocations of an infinite range of emotions via landscape, coupled with their interest in "pathetic fallacy," or the projection of human behavior into nature, strongly influenced late nineteenth-century American painting.

During the first half of the twentieth century, with the advent of Fauvism, Cubism, Surrealism, and abstract art, the image of the harmonious garden previously constructed by artists on both sides of the Atlantic was supplanted by new visions. In the early teens, Henri Matisse, Georges Braque, and André Derain, influenced by the Divisionist experiments of Georges Seurat and Paul Signac, used intense, saturated colors and a declamatory brush stroke to produce landscapes that repudiated the conventional values of pictorial coherence. In 1925, Max Ernst published his first frottage drawings (made by rubbing black chalk over paper placed atop an object, which for Ernst was often a leaf or other natural material). Ernst's poetic excursions into natural history and science reverberated in many directions, past and future. They looked back to the tradition of Vincent van Gogh's mesmeric fields and sprouting vegetation, and forward to Mark Rothko's biomorphic distortions of nature.

Georgia O'Keeffe, a native of Wisconsin, who lived also in Texas and New Mexico, devised a lexicon of nature that spoke both of her own experience as woman and of the American land. O'Keeffe was one of the very few significant American modernists who, prior to 1925, refused to go to Europe or to use any European avant-garde style. Her abstraction of nature was derived in part from artist Arthur Dove and photographer Alfred Stieglitz, and in part from her readings of Ralph Waldo Emerson and Henry Thoreau. O'Keeffe had strong feelings about certain elements of nature, especially the anatomy of flowers, in which she found analogies to the female body. Her work reveals a sense of her personal relationship with nature, which gave voice not only to the expression of a resonant feminist art, but also to a view of nature that is both disquietingly sexual and of enduring appeal. Her paintings of flowers are testimony to how an artist can interpret a subject that is considered relatively "minor" and open our eyes to a new vision, creating a new legacy for all who come after.

SANDRO BOTTICELLI

Primavera

c. 1482

TEMPERA ON PANEL, 80" × 124" (203.2 × 315CM). GALLERIA DEGLI UFFIZI, FLORENCE.

Renaissance painter Sandro Botticelli (1444–1510) was a favorite of the Medici, Florence's ruling family. According to the fifteenth-century philosopher Marsilio Ficino, *Primavera*, one of Botticelli's most celebrated paintings, is an allegory of Lorenzo di Pierfrancesco de' Medici's wedding in 1482. Set within a grove of golden orange trees that allude to the golden balls emblematic of the Medici family, this enchanted garden hosts a large cast of figures. Presiding in the center of the composition is Venus, alias Humanitas, representing the liberal arts. To her right are Mercury, the messenger of the gods, dispersing the clouds from the garden; a blindfolded Cupid shooting arrows; and the Three Graces, who personify beauty, charm, and grace, dancing. To Venus' left, the wind god Zephyrus pursues the nymph Chloris (her name is Greek for greenish-yellow), who is transformed into Flora, the goddess of spring, flowers, and gardens. The blossoms that Flora scatters upon the lawn are of the type that bloom in central Italy during the month of May, when the wedding was celebrated.

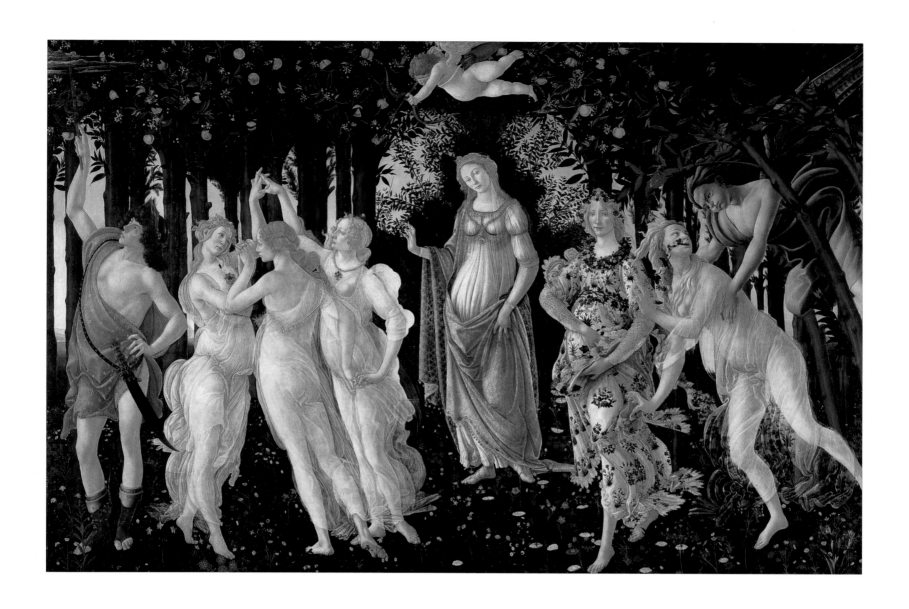

HIERONYMUS BOSCH

Garden of Delights

c. 1505–1510

PANEL PAINTING, 86 ⅝" × 38¼" (220 × 97.1CM). MUSEO NACIONAL DEL PRADO, MADRID.

*L*ittle is known of the life of Netherlandish painter Hieronymus Bosch (1450–1516), whose richly detailed

paintings were witty visual comments on the notion that moral teachings are incomprehensible to humankind. The trip-

tych known as *Garden of Delights* is considered the most puzzling and imaginative of Bosch's pictures. The iconography is

drawn from pagan garden and animal symbols and the traditions of medieval art. Although the work is filled with seem-

ingly irrational imagery, the three panels most probably refer to three gardens: the Garden of Eden, an airy landscape

filled with exotic animals and plants wherein the Lord introduces Eve to Adam; the Garden of Earthly Delights, which

depicts the erotic nature of life on earth; and the Garden of Satan, a dark place illuminated by flames and supplied with

fetishistic instruments of torture. Undoubtedly executed in the last decades of the painter's life, the triptych represents

the high point in Bosch's creation of hallucinatory landscapes.

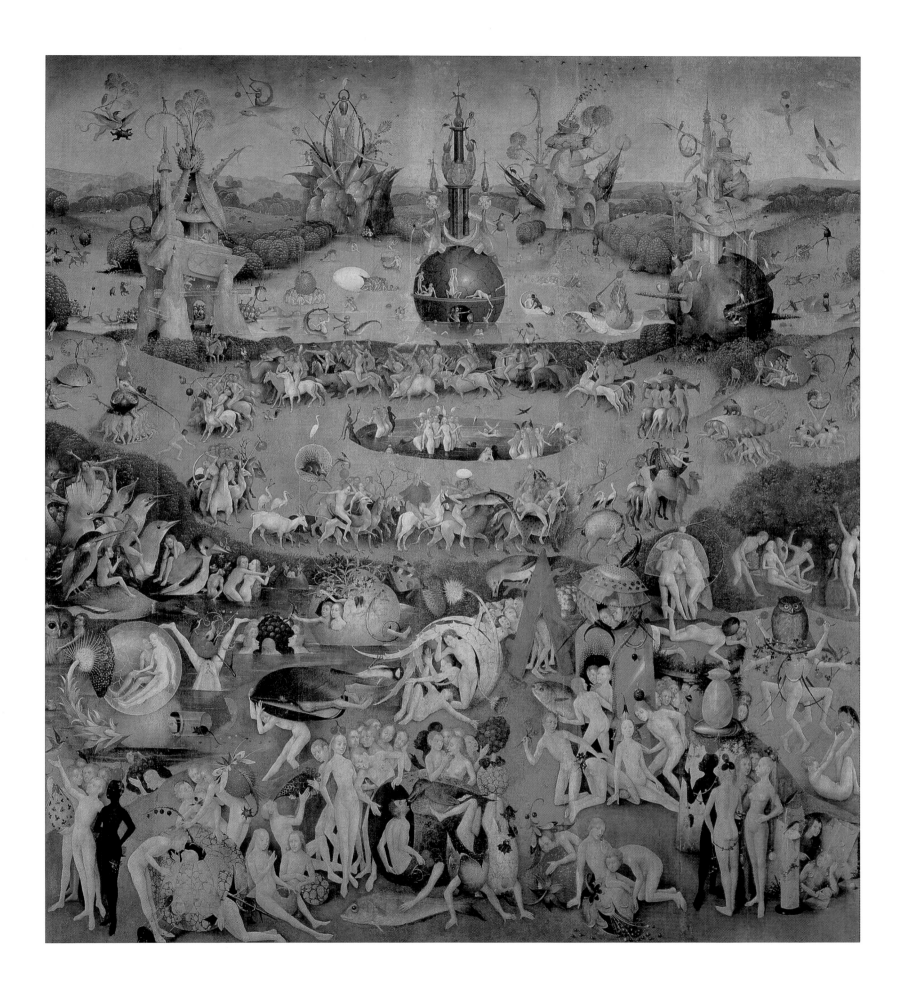

CLAUDE LORRAIN

Landscape with Nymph and Satyr Dancing

1641

OIL ON CANVAS, 39¼" × 52⅜" (99.6 × 133CM). THE TOLEDO MUSEUM OF ART.

Among the foremost landscape painters of his time, Claude Lorrain (1600–1682) evoked the idyllic aspects of nature in his work. Apprenticed to the Italian painter Agostino Tassi, Claude spent much of his life in Rome and its surrounding countryside. During a visit to the Palazzo Ludovisi in Rome, Claude apparently admired two paintings of bacchanalian subjects, Bellini's *Feasts of the Gods* and Titian's *Bacchanals*. *Landscape with Nymph and Satyr Dancing* is Claude's first picture to treat a bacchanalian motif, and his interpretation of the theme is markedly more lush and sensuous than that of other painters. The work indicates a shift from the muted light and atmospheric depiction of nature characteristic of Claude's pastoral pictures of the 1630s to the more architectural landscapes of the 1640s. The temple around which the satyrs and female figures are posed is a variant of the Temple of the Sibyl at Tivoli.

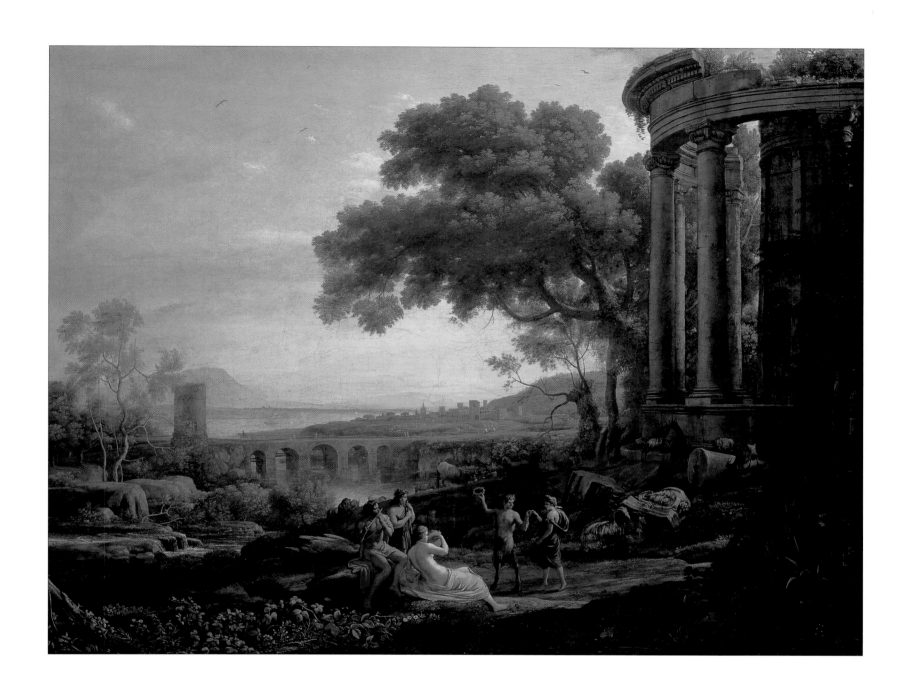

ANTOINE WATTEAU

Assembly in a Park

c. 1647

OIL ON CANVAS, 12 ³/₄" × 18 ¹/₄" (32.5 × 46.5CM). MUSÉE DU LOUVRE, PARIS.

Antoine Watteau (1684–1721) is best known as a painter of *fêtes galantes*, that is, "elegant festivals" or "gay parties." The elements of this *fête galante* are few: the park, filled with tremulous trees and a golden sunset, and the elegantly dressed people engaged in conversation. The park as a setting for figures was a novelty in eighteenth-century art. Earlier examples of people enjoying the out-of-doors were found mostly in Netherlandish genre painting or country landscapes after Titian/Giorgione's *Fête Champêtre*. One of the fascinating aspects of Watteau's *Assembly in a Park* is the collision between reality and illusion. Although at first sight the work resembles a scene from everyday life, in fact it lacks a specific narrative. Its drama derives not from anecdote or action, but rather from allegory. In this sense, the painting can be related to the tradition of medieval "gardens of love." Watteau's contribution to the "parklandscape" tradition was significant to both contemporaries like Fragonard and later artists such as Monet and his fellow Impressionists. Watteau's paintings also influenced fashion and garden design in the eighteenth century.

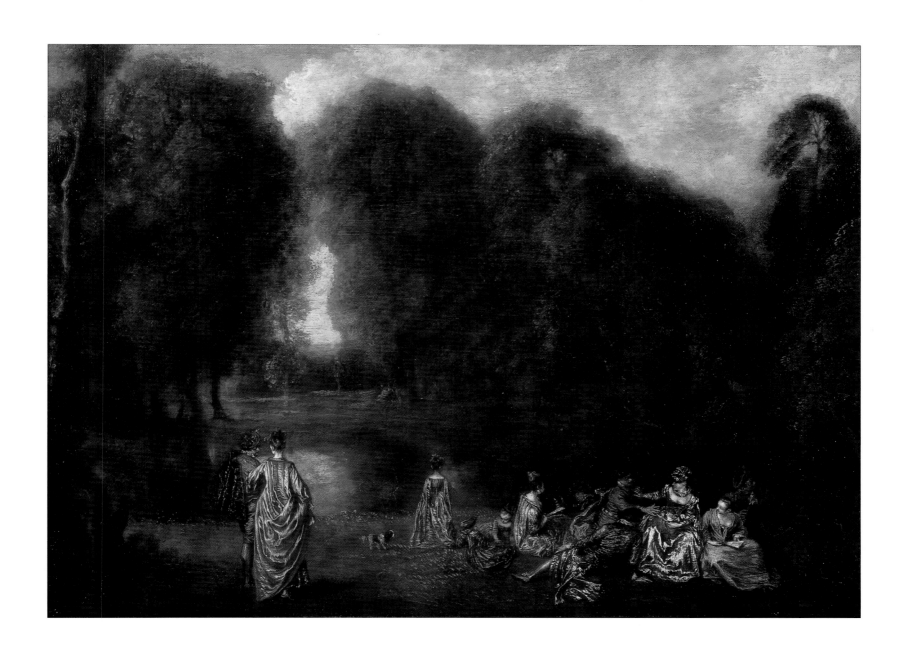

HUBERT ROBERT

Interior of a Park with Fountain

1770

OIL ON CANVAS, 16¾" DIAMETER (42.5CM). MUSÉE DE PICARDIE, AMIENS.

Hubert Robert (1733–1808) not only painted gardens, but designed them as well, and even worked on the famous gardens of Versailles near Paris. At the age of twenty-one, Robert made his first trip to Rome. There, under the influence of architect/engraver Giovanni Battista Piranesi, Robert produced a series of paintings and drawings on the theme of abandoned and imaginary gardens. Robert also painted the gardens of famous Roman mansions, such as the Villa Farnese, Villa Sacchetti, and Villa Madame. *Interior of a Park with Fountain* depicts the gardens of the Villa Barberini situated not very far from the Villa Borghese in Rome. Given his affinity for architectural ruins, it is not surprising that Robert depicted the Tritone fountain surrounded by Doric colonades and classical statues. In terms of formal treatment, the artist first determined the composition and allover disposition of light patterns in bold and unusually free brush strokes. Over this ground he added the details of the garden, giving more definition to the view.

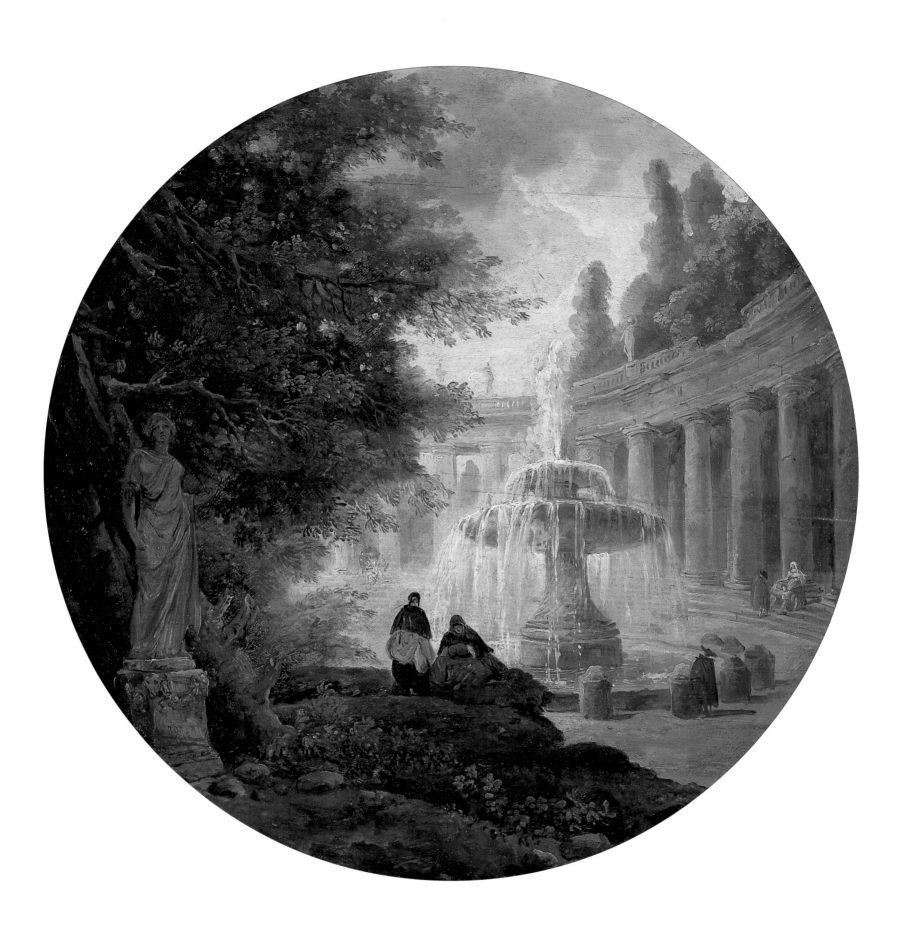

JEAN-HONORÉ FRAGONARD

The Lover Crowned

1771–1772

OIL ON CANVAS, 124" × 94⁷⁄₈" (317.8 × 243.2CM). FRICK COLLECTION, NEW YORK CITY.

Famous for his paintings of courtly love, Jean-Honoré Fragonard (1732–1806) lost this favorite subject when the French Revolution ended the monarchy, after which he moved to the countryside. *The Lover Crowned* is part of a series of paintings generically known as *The Love of Shepherds* or *The Pursuit of Love*, which was originally commissioned by the Countess du Barry (mistress of Louis XV) as a decoration for the *salon en cul-de-four* in her house in Louveciennes. Although the paintings are recognized today as Fragonard's most ambitious works, the whole series was rejected by the Countess. *The Lover Crowned* is the most passionate of the four paintings in this group, which also includes *The Pursuit*, *The Rendezvous*, and *The Love Letters*. This garden shows an exuberance of vegetation, including orange trees displayed in boxes, as well as masses of flowers bursting with movement and color. The Rococo spirit, which embraced curvaceous shapes and natural images, found vital expression in the landscapes of Fragonard.

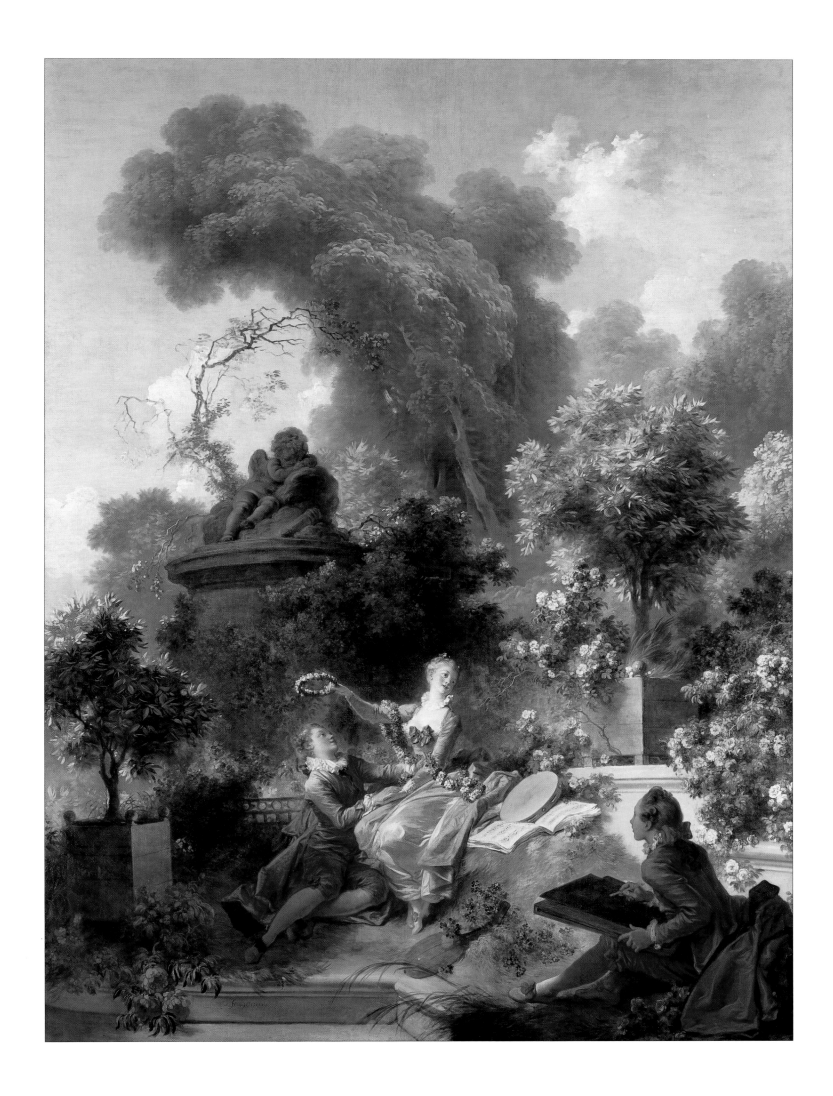

SAMUEL PALMER

In a Shoreham Garden

c. 1829

WATERCOLOR, 11½" × 8¾" (29.2 × 22.2CM). VICTORIA AND ALBERT MUSEUM, LONDON.

A disciple of the poet and engraver William Blake, Samuel Palmer (1805–1881) is best known for his ecstatic garden paintings, which were inspired partly by Blake's woodcut illustrations for Virgil's *Eclogues* and partly by the paintings of fifteenth-century Northern masters like Jan van Eyck and Albrecht Dürer. Between 1826 and 1835, Palmer worked and lived at Shoreham, in Kent, where he was associated with a group of artists called "The Ancients." During this period he executed a series of richly textured landscapes, in which trees, flowers, and all germinating vegetation are imbued with Christian symbolism. The religious aspect of Palmer's work was intensified by his reading of poets like Milton and Blake and of mystics like Swedenborg. *In a Shoreham Garden* is a visionary work that anticipates van Gogh's vital studies of nature.

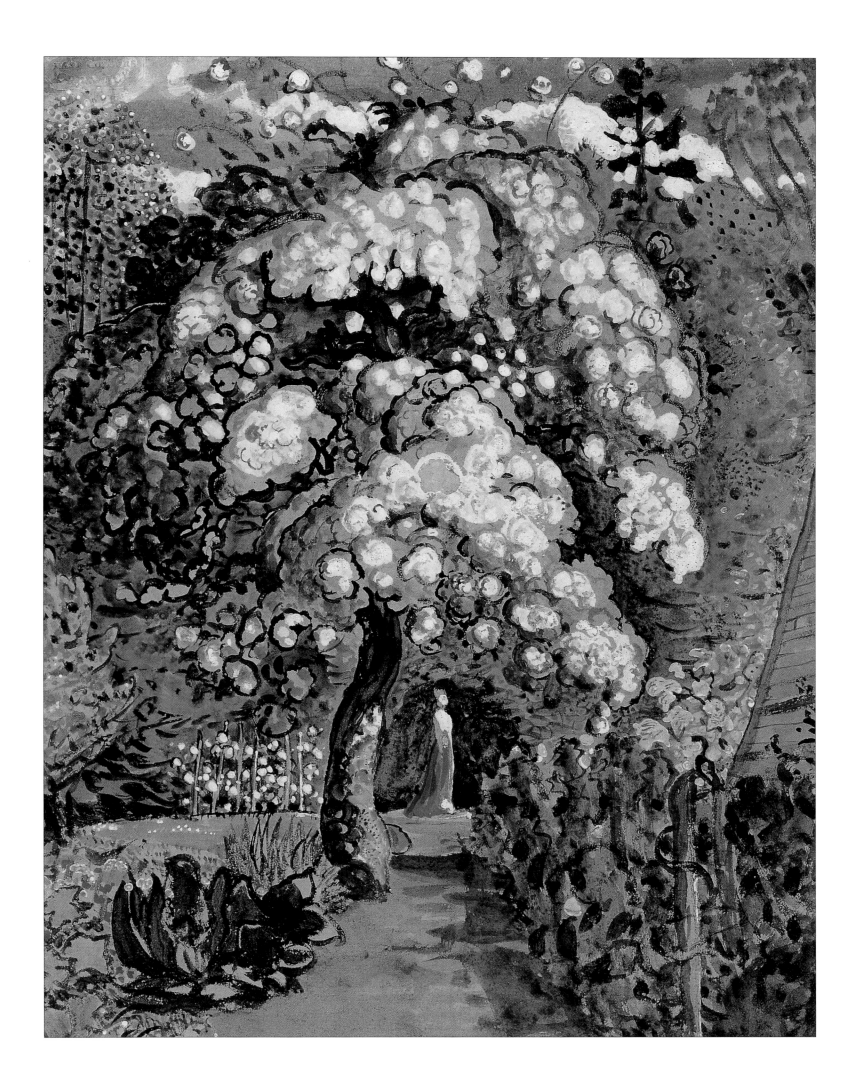

SIR JOHN EVERETT MILLAIS

Ophelia

1852

OIL ON CANVAS, 30" × 40" (76.2 × 101.6CM). TATE GALLERY, LONDON.

A prodigy who began his studies at the Royal Academy at the age of eleven, the English painter Sir John Everett Millais (1829–1896) went on to found the Pre-Raphaelite Brotherhood with Dante Gabriel Rossetti and William Holman Hunt. The Pre-Raphaelites rejected the materialism of industrialized England and admired the beauty of the works of Italian painters prior to Raphael (1483–1520). In their own work, they strove to revitalize English painting through accurate portrayals (appropriate to an age of scientific discovery), and they mixed moral and literary themes with detailed depictions of nature. Combining a Shakespearean subject with a close-up observation of natural detail, Millais' *Ophelia* remains one of the most eerie of all Pre-Raphaelite landscapes. Elizabeth Siddal, the favorite model of the Brotherhood, posed as Ophelia. Although the painting deals with the climactic moment of Ophelia's death in act 4 of *Hamlet*, the scene is conveyed without theatricality; rather, the emphasis is placed on the surroundings. The landscape was painted in the summer of 1851 on the River Ewell near Kingston-upon-Thames in Surrey. Recorded in minute detail, from the bed of weeds and water plants to the fallen tree and blossoming bushes, the setting serves not just to echo but rather to intensify the emotional tone of the scene.

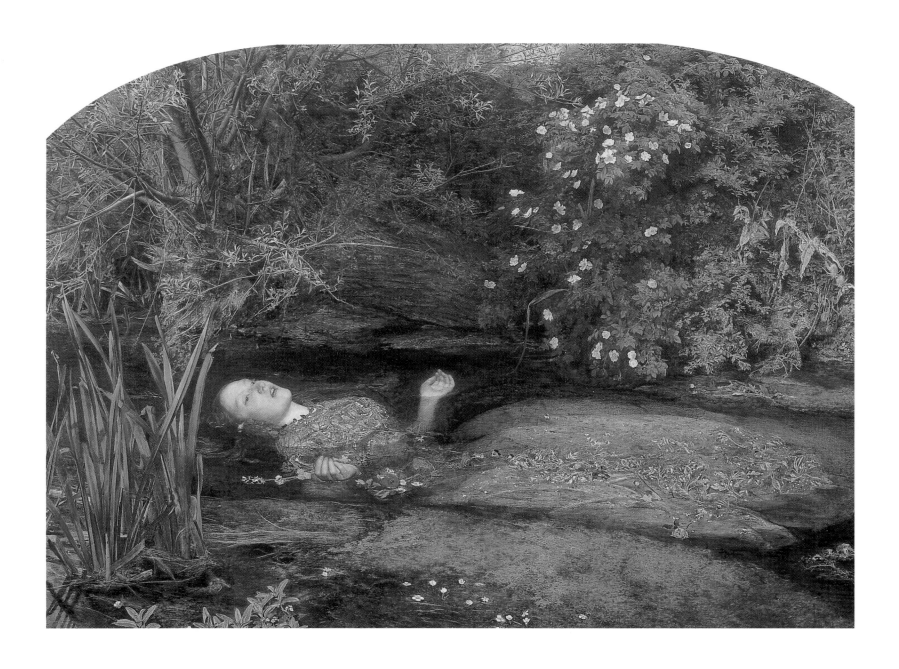

ARTHUR HUGHES

Aurora Leigh's Dismissal of Romney

1860

OIL ON CANVAS, 15¼" × 12" (38.1 × 30.5CM). TATE GALLERY, LONDON.

It has been commonly acknowledged that the English painter Arthur Hughes (1832–1915) occupies a place among the Pre-Raphaelite Brotherhood equal to that of John Keats among the Romantic poets. Hughes used Elizabeth Barrett Browning's novel in verse, *Aurora Leigh*, as the basis for his painting *Aurora Leigh's Dismissal of Romney*. Thrust into the shadow of the landscape, the crestfallen lover, shown receiving his dismissal from Aurora, is contrasted with the upright lily. Hughes' painting is executed with an exquisite sensitivity and intensity that clearly convey to the viewer the profound pain Romney is feeling. The Victorian rejection of love has never been more poignantly expressed than in the works of this subtle social commentator.

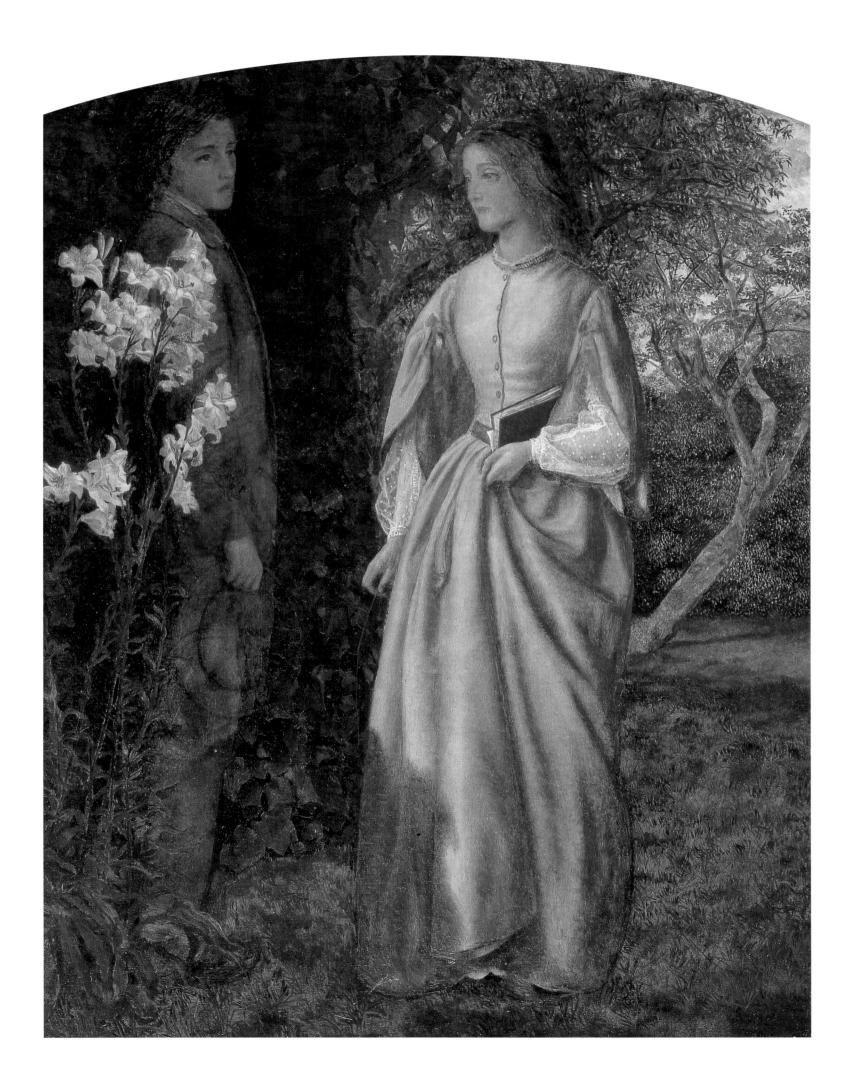

GUSTAVE COURBET

The Trellis

1862

OIL ON CANVAS, 43¼" × 53¼" (109.8 × 135.2CM). THE TOLEDO MUSEUM OF ART.

*T*n opposition to his era's popular Romantic preoccupation with imagination and emotion, Gustave Courbet (1819–1877) was firmly committed to realism, to depicting ordinary subjects in a matter-of-fact style. In 1862, Courbet went to Saintes in western France at the invitation of Etienne Baudry, an intellectual and a supporter of the arts, who was interested in botany and gardening. Baudry's extensive gardens and greenhouses inspired *The Trellis*. Between 1847 and 1860, Courbet had concentrated on painting the area near his hometown, the sweeping hills and valleys common to the landscape of Ornans; in this picture, he shows a domesticated garden. *The Trellis* features a young woman arranging flowers in a decorative cornucopia. In this close-up view, Courbet records with robust concreteness a mixed bouquet of summer flowers that has the aspect of a blossoming, outdoor still life. The sensuous surfaces of Courbet's floral composition trigger feelings of seeing and touching simultaneously.

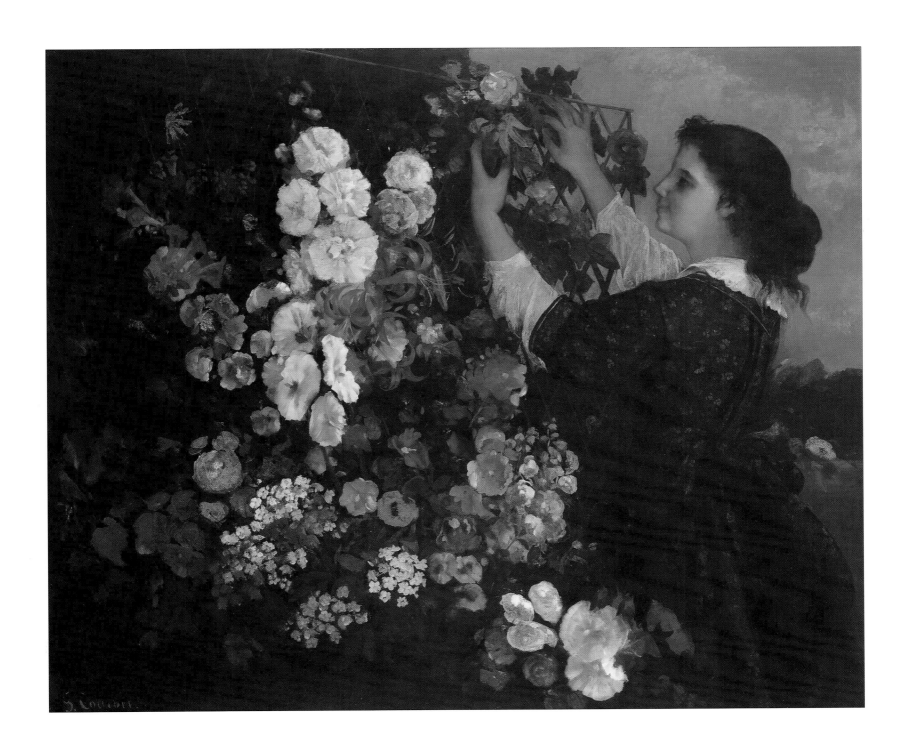

FREDERIC EDWIN CHURCH

Study of Wildflowers, Jamaica, West Indies

1865

OIL ON BOARD, 4 7/16" × 6 7/8" (11.3 × 17.4CM).
COOPER-HEWITT, NATIONAL DESIGN MUSEUM, SMITHSONIAN INSTITUTION, NEW YORK.

*N*ever before nor ever again did American painter Frederic Edwin Church (1826 –1900) approach the landscape with such intensity as in the year 1865 when he embarked upon a summer journey to Jamaica. Devastated by the deaths due to diphtheria of his two children in March of the same year, Church headed to the tropics to work, hoping to ease the pain of his tragic personal loss. Jamaica, with its rich flora, including palms, ferns, flowers, and grasses, provided the artist with the perfect setting in which he could achieve a deep and healing involvement with nature. In this seemingly near-prehistoric Eden, Church discovered a primeval atmosphere, which he captured in the lush vegetation of *Study of Wildflowers, Jamaica, West Indies.*

FREDERIC BAZILLE

The Rose Laurels

(also called *The Terrace at Meric*)

1867

OIL ON CANVAS, 56" × 98" (142.2 × 248.9CM). CINCINNATI ART MUSEUM.

In this work the French painter Frederic Bazille (1841–1870) used a view of the garden on his family estate at Meric, outside Montpellier, as subject. It is likely that the painter was working on it at the same time he was beginning *Terrace at Meric* and *Family Reunion*, two other pictures from 1867 that also use the garden as setting. The painting is unfinished and underscores Bazille's concern with harmoniously integrating the human figure into the landscape. Bazille had worked with his friend and mentor Claude Monet in the forests near Paris and on the Normandy coast, and was interested in capturing the atmospheric effect associated with the Impressionist style. During the 1860s his plein air (open air) figure pieces closely resembled those of both Manet and Monet.

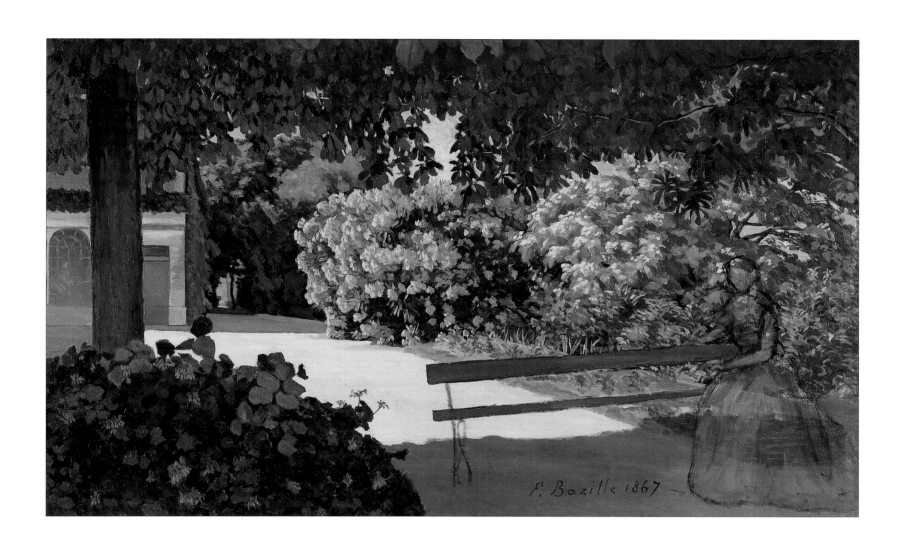

PIERRE-AUGUSTE RENOIR

Monet Working in His Garden in Argenteuil

1873

OIL ON CANVAS, 18³/₈" × 23¹/₂" (46.7 × 59.7CM). WADSWORTH ATHENEUM, HARTFORD.

At the end of 1871, Monet rented a little house in Argenteuil in order to have greater contact with nature, leaving behind a Paris devastated by the Franco-Prussian War and the Commune. The first garden Monet could call his own was in Argenteuil, where he not only painted his wife and child among the colorful flower beds, but was also himself commemorated in paintings by Edouard Manet and Pierre-Auguste Renoir (1814–1919). Renoir, although deeply attached to the city, often visited Monet and worked side by side with him, sometimes sharing the same motif and developing the Impressionist palette. In 1873, Renoir did a portrait of Monet at work in front of his easel in his garden at Argenteuil. Noteworthy is Renoir's inclusion of a view of the neighboring cottages beyond the garden. Drawing attention to the encroaching suburbia, Renoir demythologized Monet's desire, as expressed in many paintings of the same motif, to perceive the garden as a private arcadia.

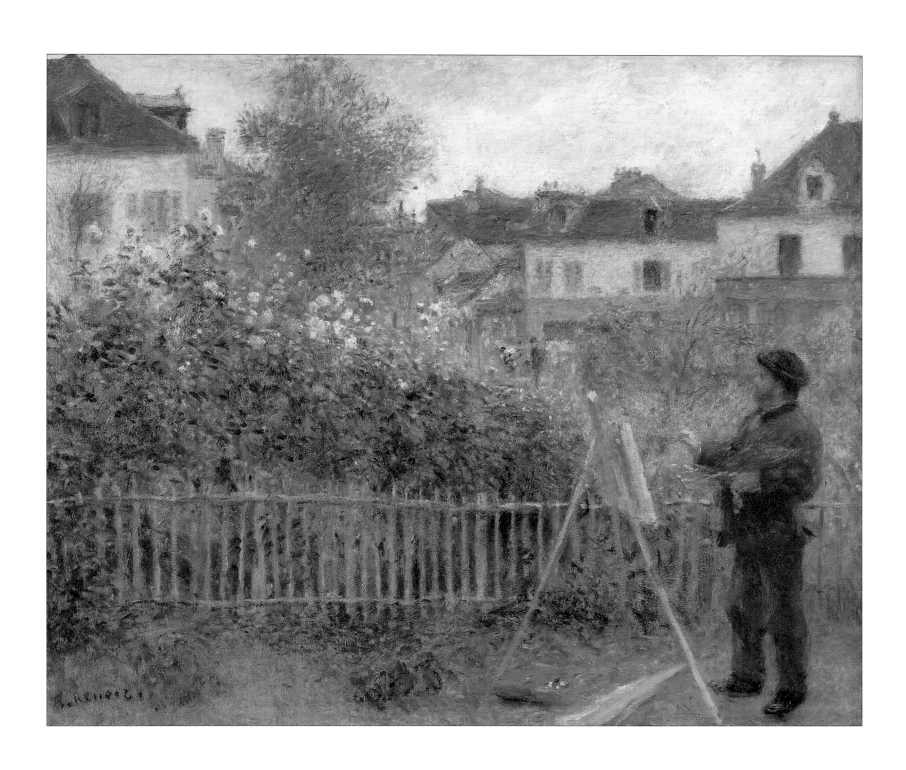

CHARLES-FRANÇOIS DAUBIGNY

Fields in the Month of June

1874

OIL ON CANVAS, 53" × 88" (134.6 × 223.5CM).
HERBERT F. JOHNSON MUSEUM OF ART, CORNELL UNIVERSITY, ITHACA, NEW YORK.

Charles-François Daubigny (1817–1878) was the youngest of the Barbizon artists, a group of French painters who rebelled against the conventions of classical landscape painting and chose instead to represent nature directly. Working in and around the forest of Fontainbleau before 1850, Daubigny, more than any other painter in the century, worked in nature and from nature in order to obtain unity of impression. His plein air style played a key role in France, specifically as a model for Monet, and also in America, for the generation of the Hudson River School. His *Fields in the Month of June* was painted in the year of the first Impressionist group exhibition. The strongly pigmented fields of red poppies and the atmospheric color passages in the sky announce the variety and richness of effect that was associated with the Impressionist movement.

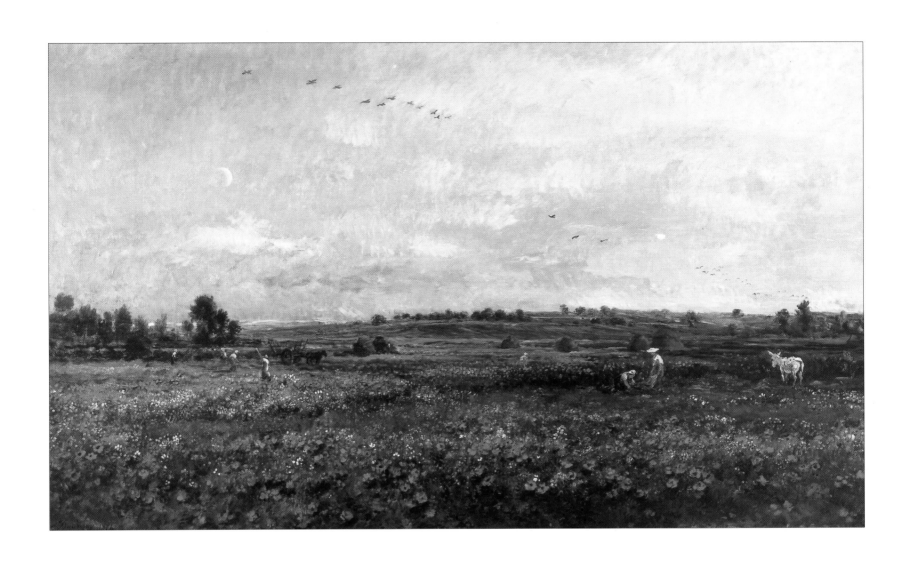

CLAUDE MONET

Gladioli

c. 1876

OIL ON CANVAS, 22" × 32½" (56 × 83CM). THE DETROIT INSTITUTE OF ARTS.

The Impressionist Claude Monet (1840–1926) is, perhaps, the world's most famous and well loved painter of gardens. Throughout his life, the artist attempted to express in paint his experience of nature; his colorful, light-filled landscapes are among the most popular in the history of painting. A founder of Impressionism, Monet rejected the academic approach to landscapes and regularly painted in the open air, often depicting his own garden. The garden was Monet's favorite painting motif at Argenteuil, Vétheuil, and Giverny. In *Gladioli* he depicts his wife Camille as an element of the garden. Her figure, with patches of light playing across it, is totally absorbed into the surroundings. In fact, it is the oval flower bed filled with geraniums, ground ivy, and tall spikes of gladioli occupying the foreground space that is the true subject of the work. Monet's brush stroke is differentiated in order to suggest the specificity of natural textures, but the overall effect is of pulsating color. The ideas of creating a total atmospheric envelope, of melting together flowers with figure, and of dissolving all boundaries between the elements of nature are characteristic of Monet's works of the 1870s.

JAMES TISSOT

The Picnic

c. 1876

OIL ON CANVAS, 30" × 39¹/₈" (76.2 × 99.3CM). TATE GALLERY, LONDON.

Born in France, James Tissot (1836–1902) lived in London for many years before moving to Palestine to paint

Biblical scenes. Best known as a painter of modern Victorian life, Tissot often portrayed elegant people engaged in

leisurely activities such as drinking tea in a conservatory, strolling through the park, taking a trip down the Thames, or,

as here, enjoying a picnic by an ornamental pool. *The Picnic* is set in Tissot's own stylish garden, which functions as back-

ground for the fashionable denizens of society who populate it. The men's caps are those of the old Etonian cricket team

known as I Zingari, with which the artist was familiar from watching the action at a neighboring cricket ground. Tissot

carefully portrays the dress, habits, and preoccupations of the age, but beneath the deceptively glossy elegance, there

is a hint of ennui. Although they are engaged in pleasurable activities, the figures do not seem to be truly enjoying

themselves. The autumnal colors of the garden underline this somewhat melancholy mood.

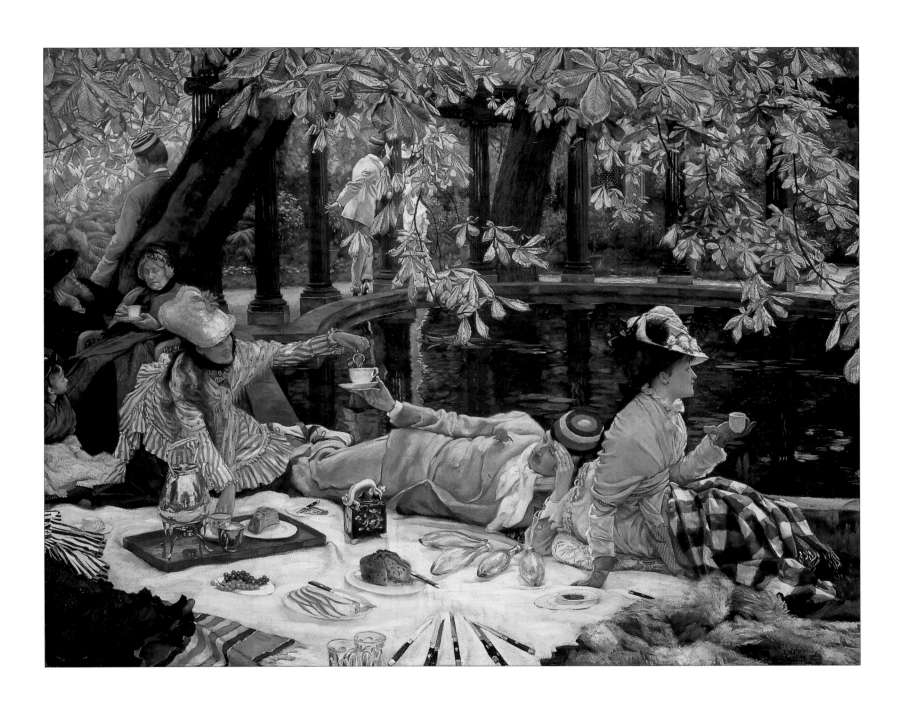

JOHN SINGER SARGENT

Carnation, Lily, Lily, Rose

1883–1886

OIL ON CANVAS, 68¹/₂" × 60¹/₂" (171.2 × 151.2CM). TATE GALLERY, LONDON.

By the mid 1880s, American artists had begun to embrace French Impressionism, and within a few years developed their own versions of the style. John Singer Sargent (1856–1925) was among the first to explore this new style in *Carnation, Lily, Lily, Rose*, an evocation of nature in the light of early evening. The painting represents Sargent's debut at the Royal Academy in 1887, one year after he moved to London. As an attempt to deal with a modern-dress subject—young girls lighting Chinese lanterns in the garden—the work is indebted to Monet's large figure pictures. In 1887, Sargent visited and worked with Monet at Giverny. In 1889, the two painters exhibited together, and subsequently Sargent purchased four of Monet's works, thus underscoring his sustained admiration of the French master. However, because of his strict Academy training, Sargent remained a "holiday" Impressionist, adopting the light, plein air brushwork style only occasionally, and successfully making his reputation as a professional painter of dashing portraits.

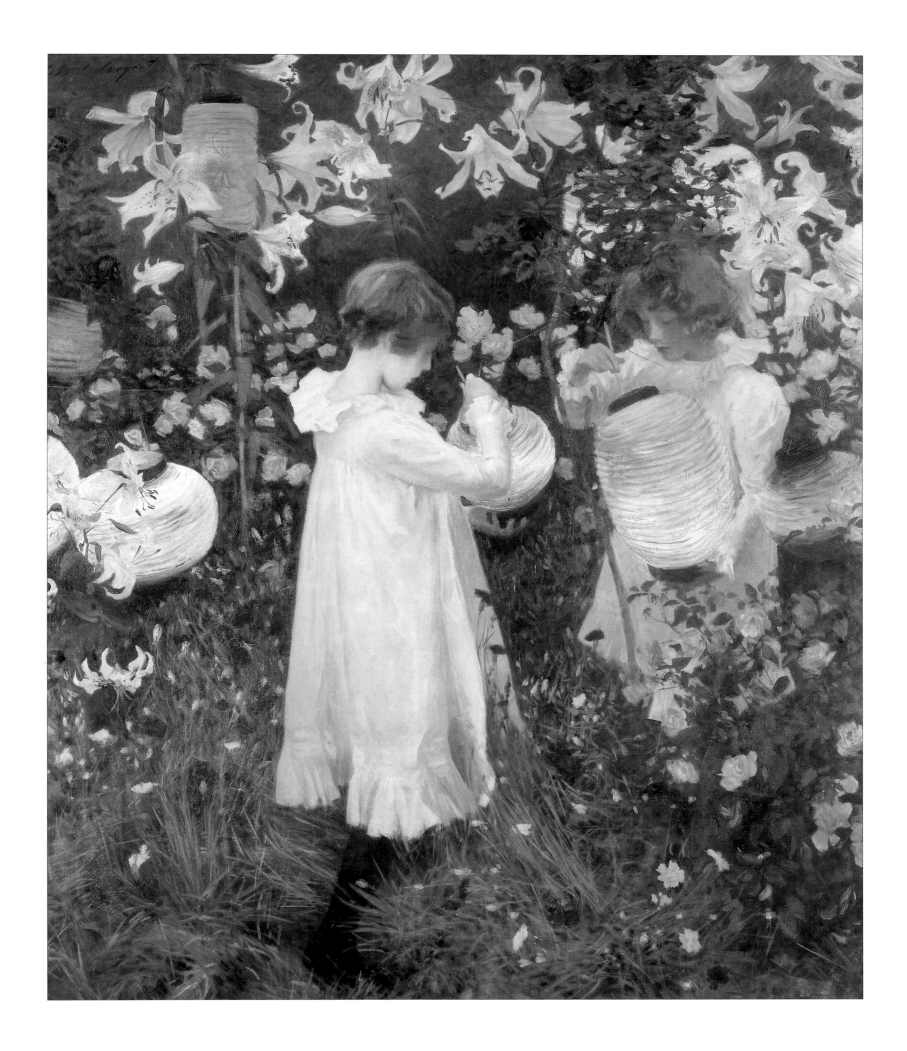

WILLIAM MERRITT CHASE

The Open Air Breakfast

c. 1888

OIL ON CANVAS, 37 7/16" × 56 3/4" (95 × 144.1 CM). THE TOLEDO MUSEUM OF ART.

Although he was born in Indiana, William Merritt Chase (1849–1916) lived most of his life in New York.

Between 1886, when he moved with his wife to the fashionable Park Slope section of Brooklyn, and 1890, Chase

painted a series of views of his surroundings, especially of Prospect Park in Brooklyn and Central Park in New York

City. These views of nature were executed quickly, often out-of-doors, and although they took as their subject the

American landscape, they were indebted to the tradition of park scenes by Manet, Degas, Renoir, and Monet. *The Open*

Air Breakfast, set in the painter's own backyard in Brooklyn, depicts members of his family enjoying a summer day in their

garden, which is filled with picturesque furnishings and a variety of flowers, including geraniums and roses. Chase's

domestic arcadia presents a world of calm elegance and decoratively posed figures painted in quick, small brush strokes,

carefully controlled.

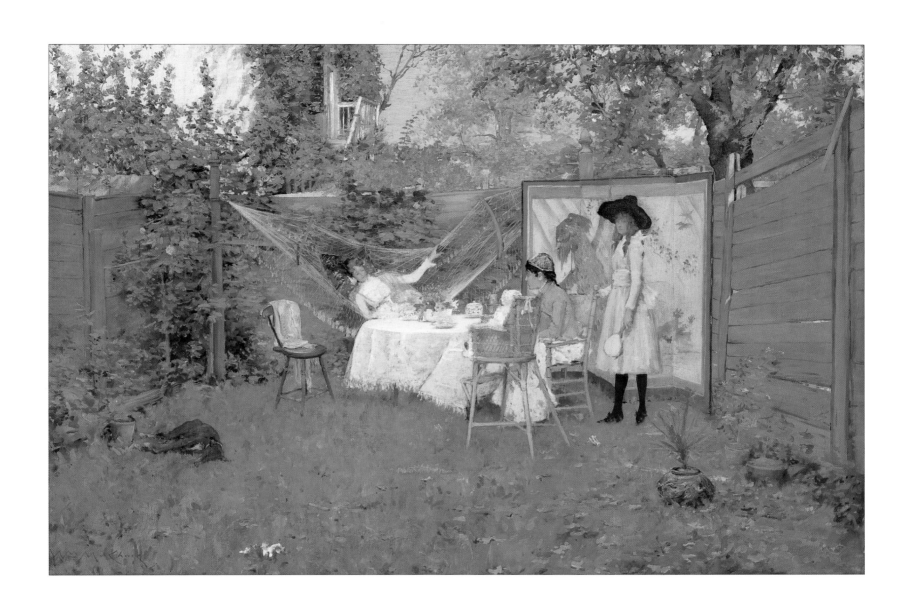

VINCENT VAN GOGH

The Orchard

1888

OIL ON CANVAS, 25³/₄" × 31⁷/₈" (65.4 × 81 CM). VAN GOGH MUSEUM, AMSTERDAM.

The great Dutch painter Vincent van Gogh (1853–1890) had a painting career that lasted only a decade; some of his most brilliant works were executed during the two years he spent at Arles in the south of France. He painted fourteen canvases of orchards in blossom within the first month of his arrival in Arles in 1888. Each orchard in the series is a portrait of the Provençal landscape. After the winter months spent in Paris, the intoxicating colors of the Midi in springtime under pure blue skies filled van Gogh with sensations of new life and vitality. The scenes of unpeopled, blooming orchards are related to Japanese prints; in fact, in a letter to his brother, Theo, the artist described the Midi region as being similar to Japan. In the late 1880s, Japanese art enjoyed an enormous popularity in France, and van Gogh was among the first artists to have copied prints by the Japanese artists Hiroshige and Hokusai. Van Gogh even called the Impressionists "the Japanese of France," and his paintings of orchards fuse the sensibilities of both traditions.

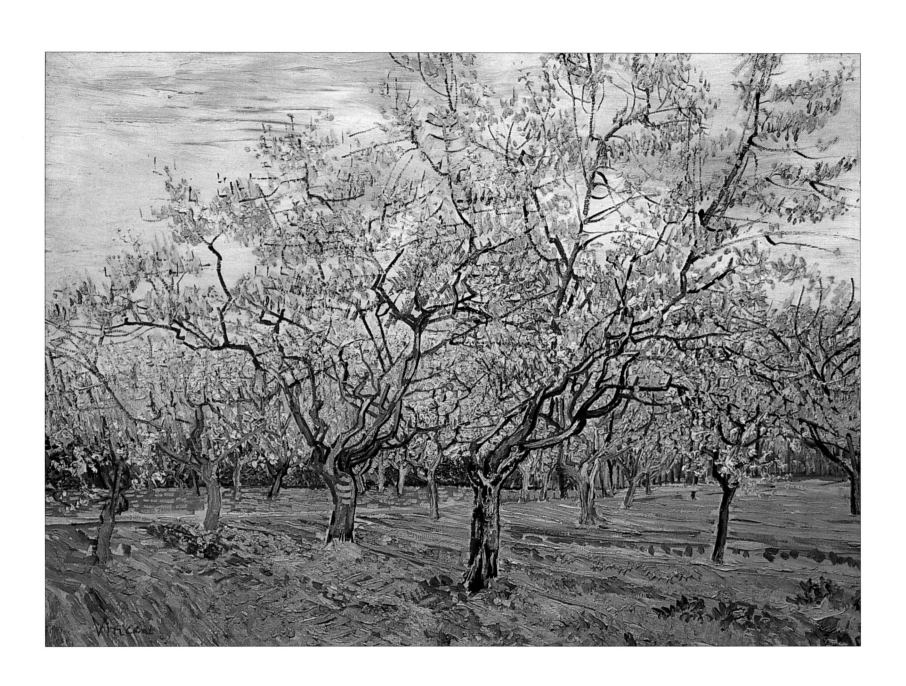

CHILDE HASSAM

Celia Thaxter in Her Garden

1892

OIL ON CANVAS, 22⅛" × 18⅛" (56.1 × 46CM).
NATIONAL MUSEUM OF AMERICAN ART, SMITHSONIAN INSTITUTION, WASHINGTON, D.C.

Childe Hassam (1859–1935) was an American painter known for his lively landscapes. Celia Laighton Thaxter was one of Hassam's students in the watercolor classes he conducted in Boston during the early 1880s. She was also a writer who cultivated a rich garden around her cottage on Appledore Island in the Isles of Shoals off New Hampshire. This was the site where every summer she liked to organize an informal salon for her artist and literati friends from New England and New York. In 1892, Hassam began working on illustrations for Thaxter's collection of poems, *An Island Garden*, which sings the beauty and spirituality of flowers. *Celia Thaxter in Her Garden* is an example of American Impressionism, a style that Hassam developed during his second sojourn in France between 1886 and 1889.

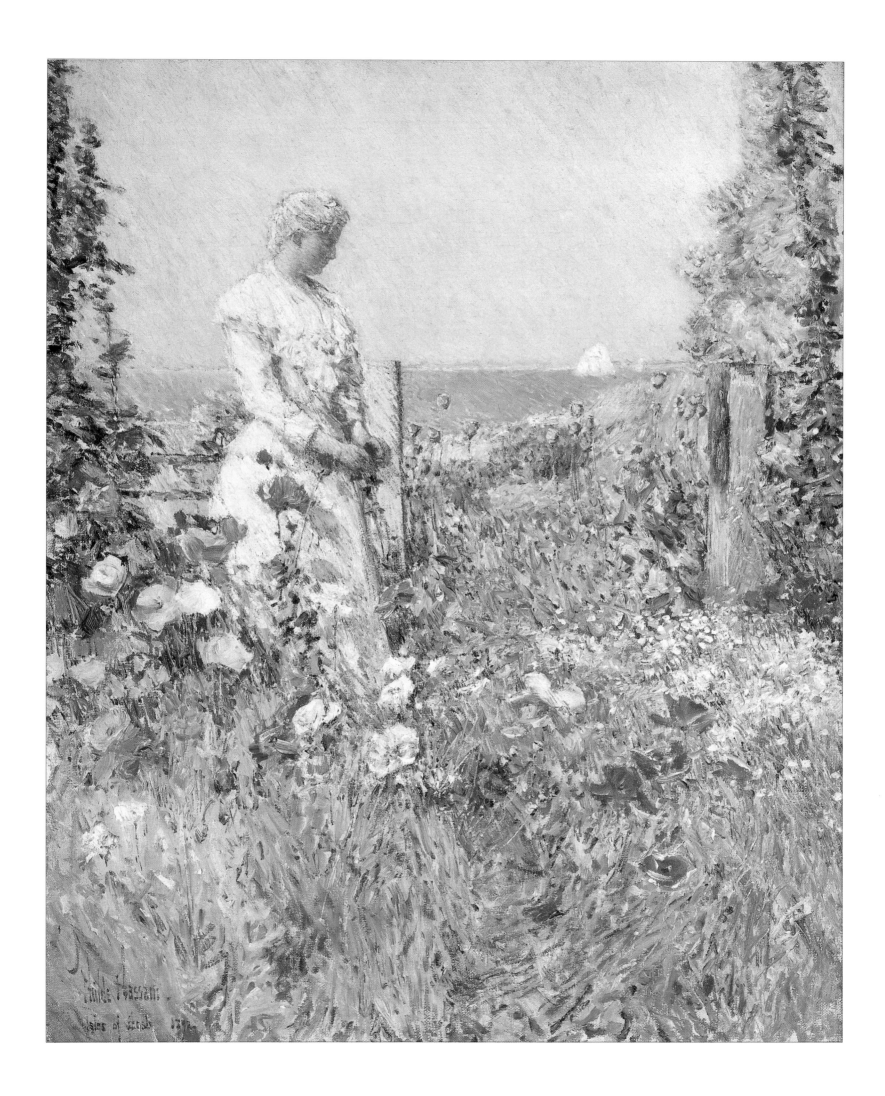

PAUL SIGNAC

Place des Lices, Saint-Tropez

1893

OIL ON CANVAS, 25 3/4" × 32 3/16" (65.4 × 81.8CM). THE CARNEGIE MUSEUM OF ART, PITTSBURGH.

The French painter Paul Signac (1863–1935) first began to use small divided strokes in his paintings in the spring of 1886. Two years later, he began collaborating with the color theorist Charles Henry, whose influential work played an instrumental part in the development of Neo- or Postimpressionism. Signac disseminated the tenets of Divisionism, a technique of small dabs or dots of pure color that were intended to be mixed in the viewer's eye and create an intense experience of color. In 1892, Signac began to use his villa at Saint-Tropez on the Mediterranean as a base for summer travels. *Place des Lices* exemplifies the use of rich color contrasts on which Signac, and subsequently his friend and disciple, Henri-Edmond Cross, built their work. Signac's antinaturalist harmonies are evident in the foliage above the park bench, where the swirling dots of pigment change direction according to the surface pattern rather than to any movement of leaves in reality.

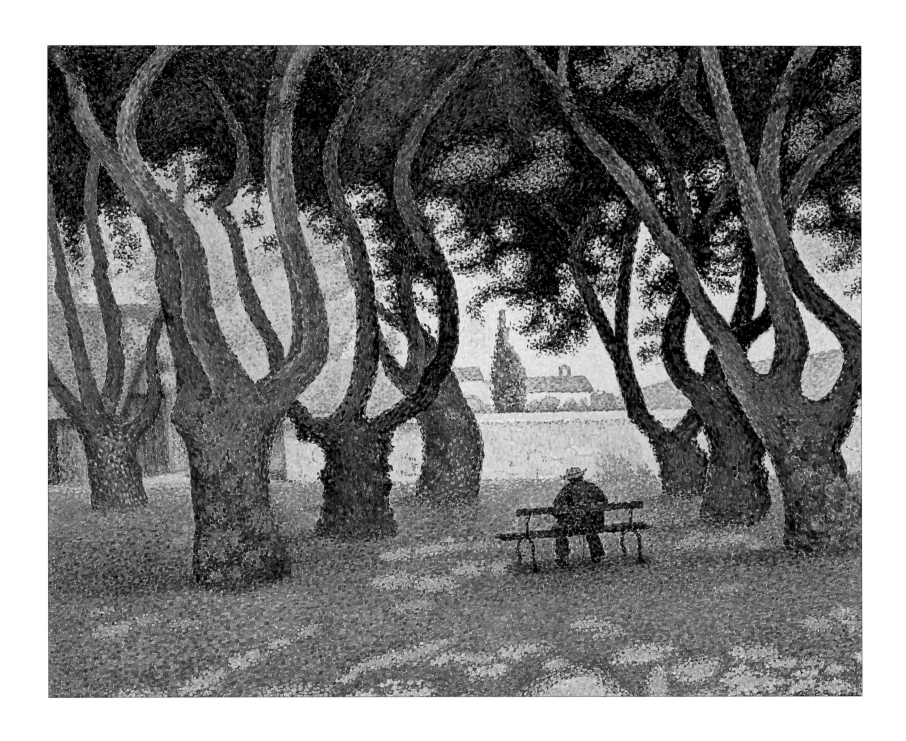

Gustav Klimt

Garden with Sunflowers

(also called *The Sunflowers*)

c. 1905–1906

Oil on canvas, 56" × 98" (142.2 × 248.9cm). Österreichische Galerie, Vienna.

The richly ornamental asymmetry of the works of Gustav Klimt (1862–1918) identifies him as a spokesperson of the art nouveau style. In his interpretation of the garden motif, the shadowless field of flowers, the spaceless play of neatly aligned strokes, and the agitated rhythms of color create a wallpaper effect, loosely derived from Neoimpressionism.

The closely packed profusion of flowers in this painting is ordered and decorative, with each region of the garden defined by its own characteristic shapes and color schemes. Klimt creates an image of luxuriant growth that draws on the styles of the past, including sources as diverse as van Gogh's highly individualized studies of flowers and Japanese prints, while also providing a Jugendstil ("young style," an Austrian reference to art nouveau) reevaluation of the garden painting.

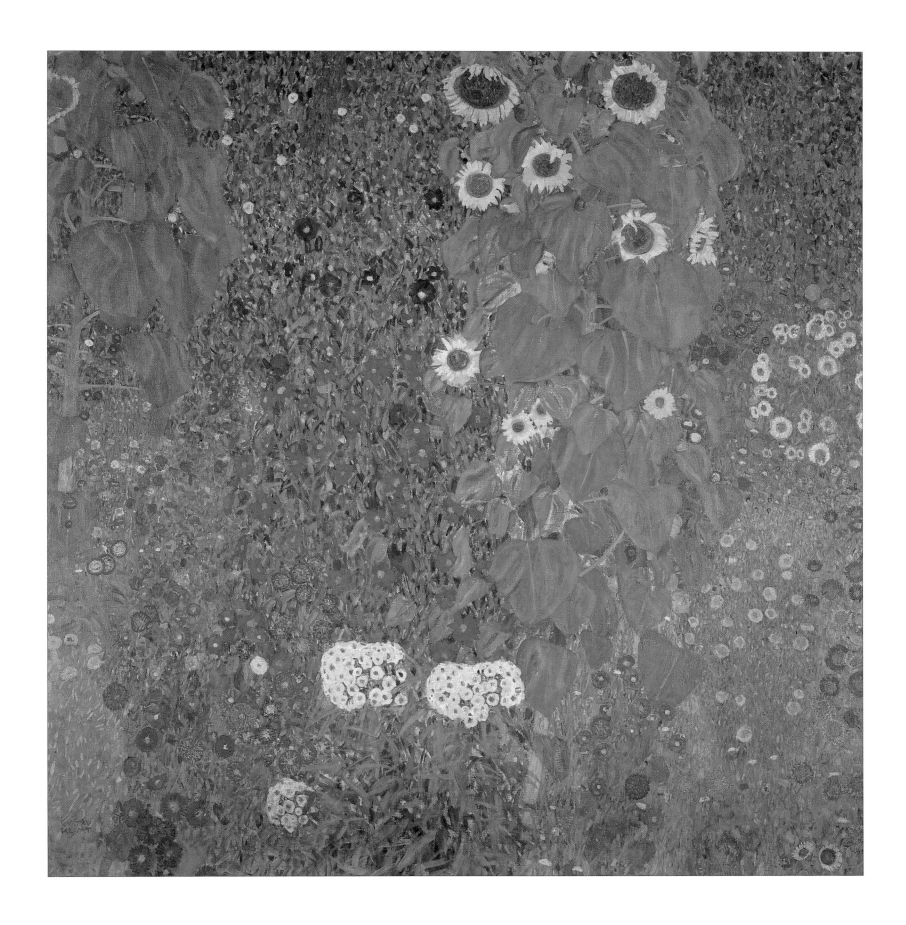

HENRI MATISSE

Joy of Life

1905–1906

OIL ON CANVAS, 69⅛" × 94⅞" (175.5 × 241 CM). THE BARNES FOUNDATION, MERION STATION, PENNSYLVANIA.

The only painting that Henri Matisse (1869–1954) exhibited at the Salon des Indépendants in 1906, *Joy of Life*, combines the Divisionist "dot" with the lively brush strokes of Fauvism. (The Fauves, "wild beasts," were a group of painters whose bold, exuberant colors and distorted shapes shocked art critics of the early 1900s.) It also conveys precisely the feeling of its title, a great sense of joy in living. The arcadian setting is inhabited by happy groups of male and female nudes, playing music, dancing in a ring, embracing, picking flowers, and relaxing on the grass. Thematically, the picture draws on the pastoral-bacchanalian landscapes of Giorgione, Titian, and Bellini. *Joy of Life* is a manifesto-painting, which contains a whole repertoire of motifs from which Matisse drew in the following years.

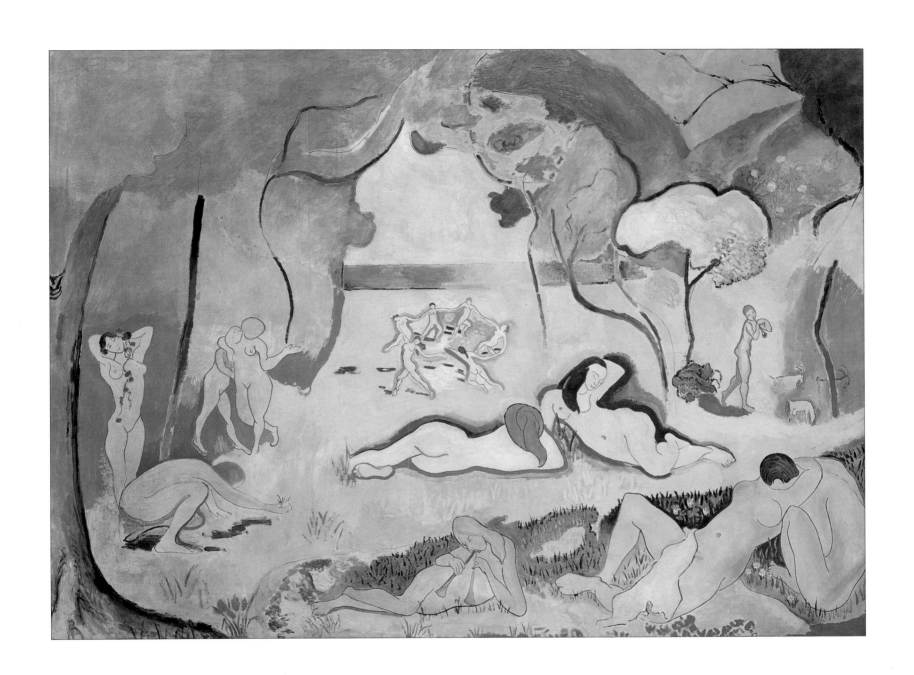

GEORGES BRAQUE

Olive Trees

1907

OIL ON CANVAS, 15" × 18 3/16" (38.1 × 46.2CM). WORCESTER ART MUSEUM, MASSACHUSETTS.

Georges Braque (1882–1963), Raoul Dufy, and Othon Friesz represent the Norman Fauves, a group of French artists who pioneered a sense of the new through their radical application of saturated color and anarchist brush strokes in the depiction of the working port of their hometown, Le Havre, and of other seaside resorts on the coast of Normandy. The Fauves Havrais studied with Charles Lhuillier, who favored the presentation of landscapes in an atmospheric style derived from Impressionism. *Olive Trees*, executed in the summer of 1907 at La Ciotat, underscores Braque's encounters with the work of Matisse and other mainstream Fauve painters. The intensified color relationships indicate an abandonment of naturalism in favor of an expressive palette and gestural style that mark a stylistic breakthrough in landscape painting. Braque went on to explore form and structure, collaborating with Picasso in the development of Cubism and collage.

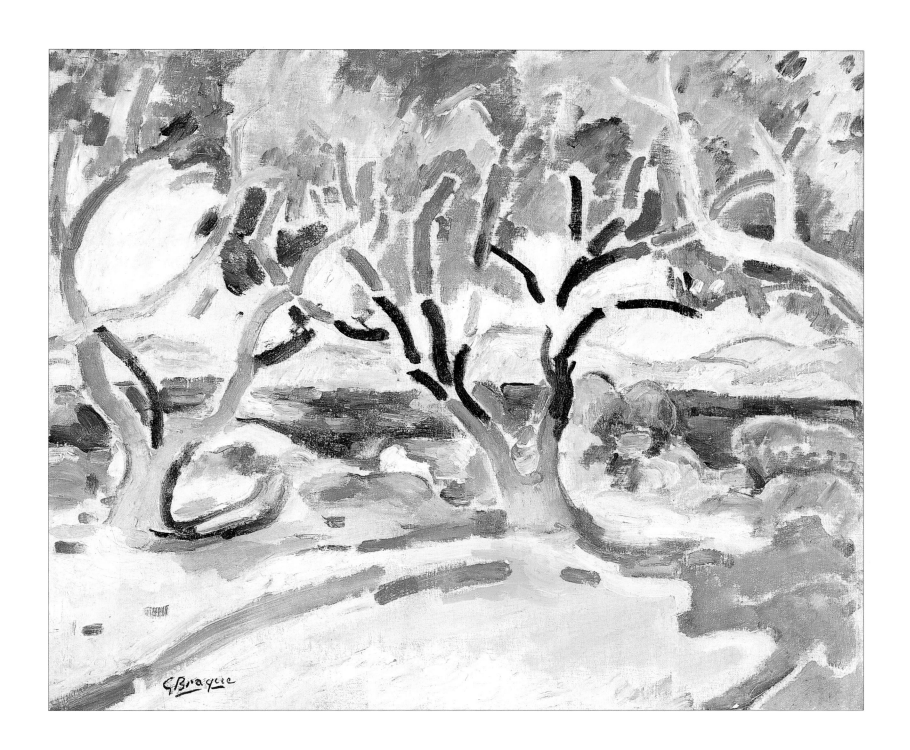

HENRI MATISSE

Harmony in Red

1908

OIL ON CANVAS, 69 3/4" × 85 7/8" (177.1 × 218.1CM). THE HERMITAGE, LENINGRAD.

The theme of *Harmony in Red* is the dialogue between the natural world and the domestic interior. The artist plays with the shifting identities of the garden seen through the window and with the assertive patterns of the wallpaper and cloth design in the room. The blue-on-red ornament, which is the predominant motif in the picture, derives from a roll of printed fabric that Matisse occasionally used as a backdrop for still-life compositions. Matisse's interest in Eastern decorative arts and his attraction to exotic textiles are employed in the service of infusing life and organic rhythm into inorganic and abstract matter. The collision between the blossoming trees in the garden outside and the floral patterns of the domestic interior imparts to the picture energy and life.

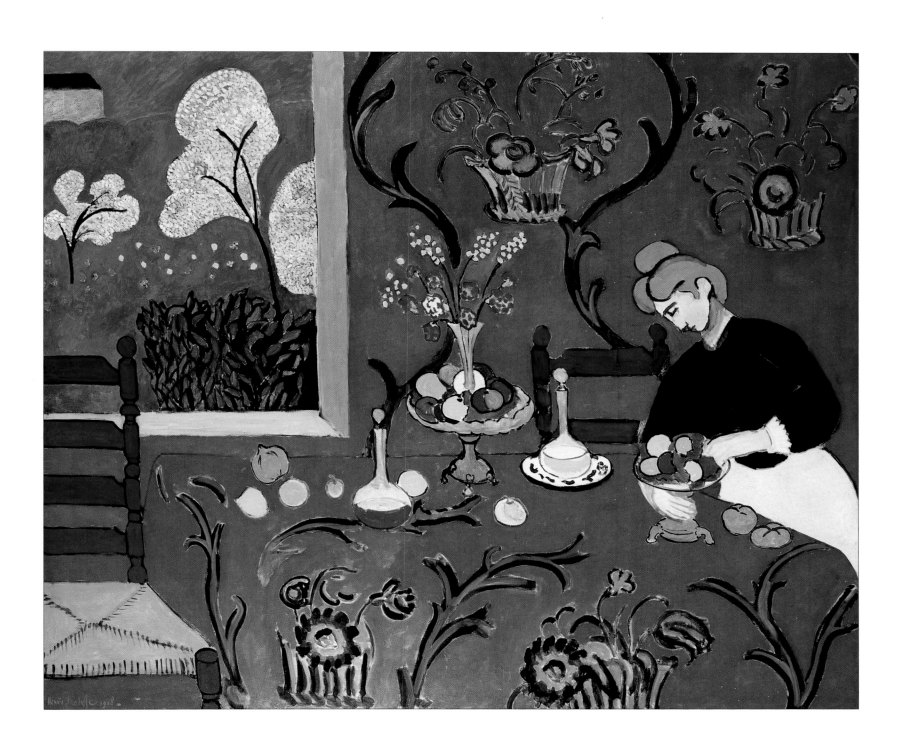

HENRI ROUSSEAU

The Dream

1910

OIL ON CANVAS, 80½" × 117½" (204.4 × 298.4CM). THE MUSEUM OF MODERN ART, NEW YORK.

Completely self-taught, Henri Rousseau (1844–1910) was a customs official in Paris who began painting in middle

age. His remarkable, enchanted landscapes come not from nature but from the imagination, and are infused with great

feeling. *The Dream* is the largest of Rousseau's paintings, and according to a letter written by the artist in 1910 to the art

critic André Dupont, it represents a woman dreaming that she has been transported to the midst of the jungle. Rousseau,

who never traveled to any exotic parts of the world, extrapolated the tropical scene from frequent visits to the Botanical

Gardens in Paris. Much admired by the writers Guillaume Apollinaire and André Breton, *The Dream* juxtaposes incon-

gruous elements such as a female nude posed on a Louis-Philippe couch (which recalls Eve via the many Venuses of the

Renaissance, Goya's Majas, and Manet's *Olympia*) with the luxurious flora and fauna of a jungle-Eden. The dreamlike

combination of elements anticipates the later Surrealist device of "automatic collage."

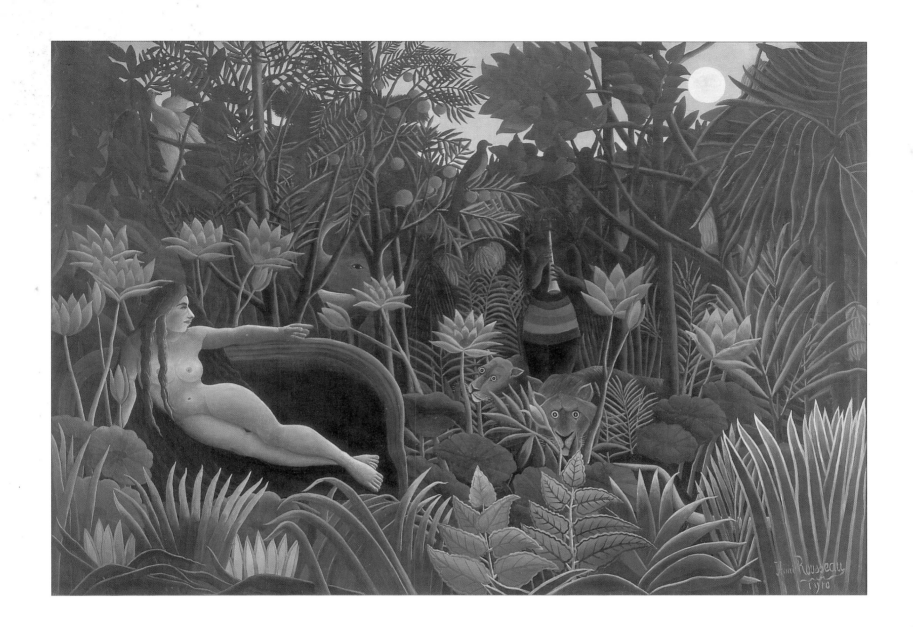

Marc Chagall

Temptation

(also called *Adam and Eve*)

1912

Oil on canvas, $63^{3/16}''$ × $44^{7/8}''$ (160.5 × 114cm). The Saint Louis Art Museum.

Born in Russia, Marc Chagall (1887–1985) emigrated to France in 1910, and spent most of his life there. His paintings frequently drew on memories of his Russian boyhood and Jewish life and lore. *Temptation* was exhibited at the Salon des Indépendants of 1913 and represents one of Chagall's most successful experiments with the Cubist approach of geometricizing figures and landscape into fragmented planes. Reinterpreting the familiar theme of Adam and Eve in the Garden of Eden, Chagall included a portrait of his bride, Bella, and himself holding a bouquet of flowers in a delightful vision of paradise.

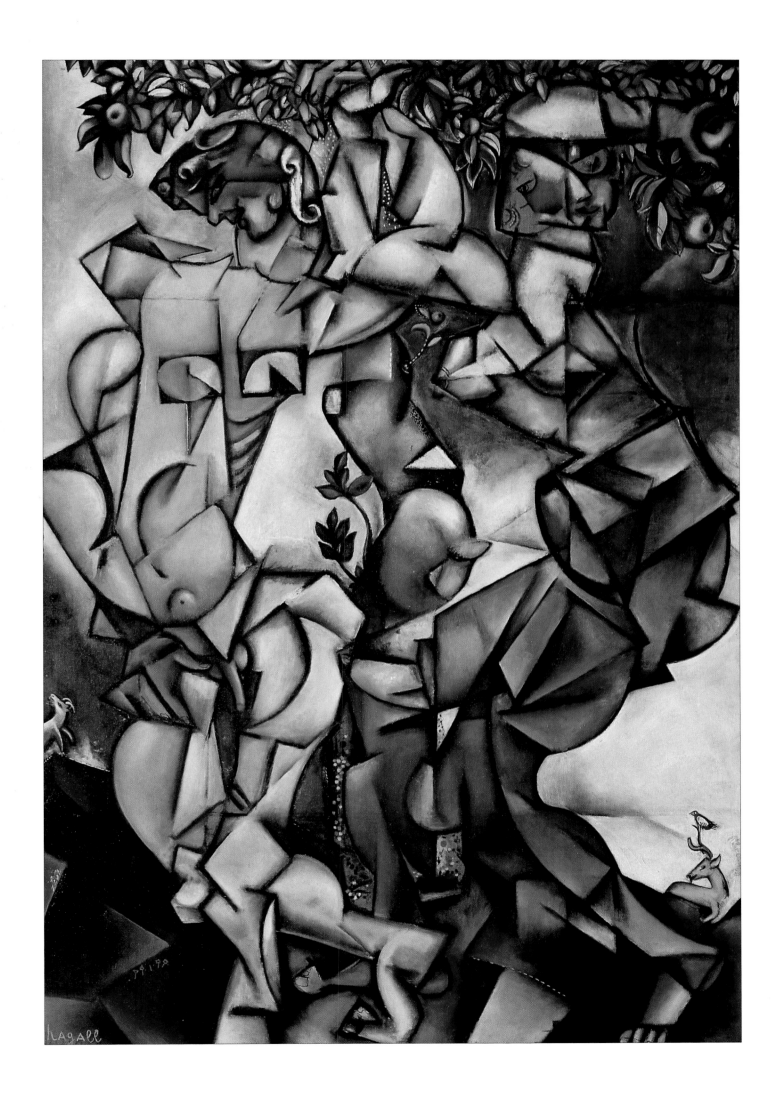

ARTHUR G. DOVE

Plant Forms

c. 1912

PASTEL ON CANVAS, 17¼" × 23⅞" (43.8 × 60.6CM). WHITNEY MUSEUM OF AMERICAN ART, NEW YORK.

*A*lthough his works were inspired by a profound feeling for nature, Arthur G. Dove (1880–1946) was one

of the first American artists to develop a nonobjective style. In 1910, at about the same time Wassily Kandinsky was

investigating abstract art in Europe, Dove produced his first abstract paintings. By 1911, he had turned to pastel as an

appropriate medium for his perceptions of the natural world. *Plant Forms* is among a group of pastels painted between

1912 and 1918 while Dove lived on a farm in Westport, Connecticut. Dove's landscape is made of layers of swelling veg-

etation, defined by gradations of tone that not only contrast with the more geometric precision of contemporary French

Cubism, but actually succeed in formulating a truly American vision. Both Dove and the painter Georgia O'Keeffe were

associated with the photographer Alfred Stieglitz and his group of American modernists, who avidly studied and

produced abstract works.

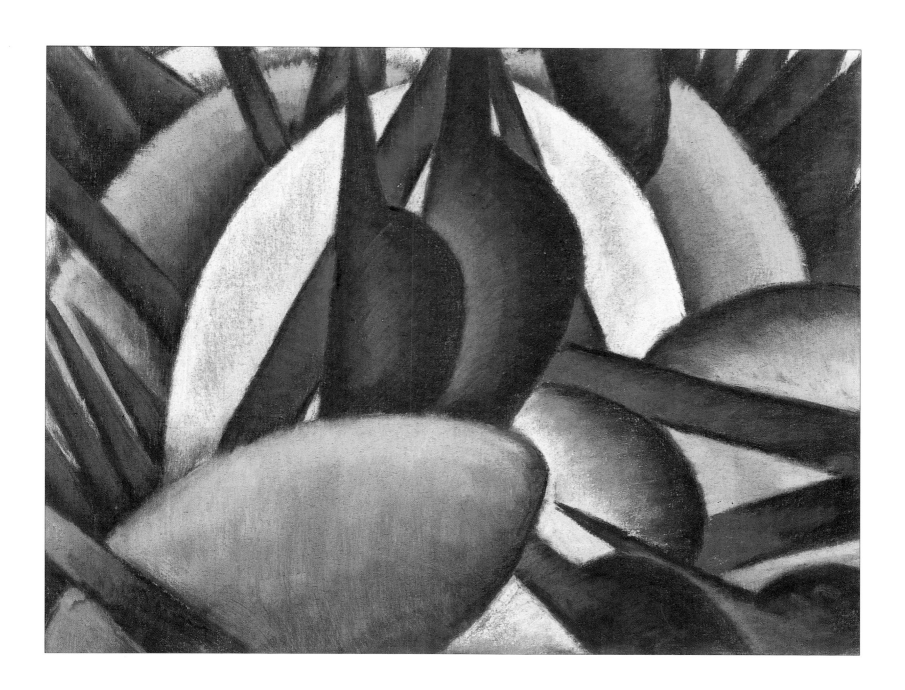

CHARLES BURCHFIELD

Noontide in Late May

1917

WATERCOLOR AND GOUACHE ON PAPER, 21 $\frac{5}{8}$" × 17 $\frac{1}{2}$" (54.9 × 44.5CM).
WHITNEY MUSEUM OF AMERICAN ART, NEW YORK.

American painter Charles Burchfield (1893–1967) believed the year 1917 to be the "golden year" of his artistic career. Certainly, this painting, which he described in a note on the back of the work as "an attempt to interpret a child's impression of noon-tide in late May," is a poetic evocation of nature. The trend toward expressionism that Burchfield initiated in 1916 was now given full force with brushed colors applied freely and directly on paper; indeed, the graphic stylization of trees and flowering bushes in *Noontide in Late May* borders on abstraction. Painting in his own backyard garden in Ohio, Burchfield evinces a feeling of nature that is both vital and exotic in its effective mixture of reality and imagination.

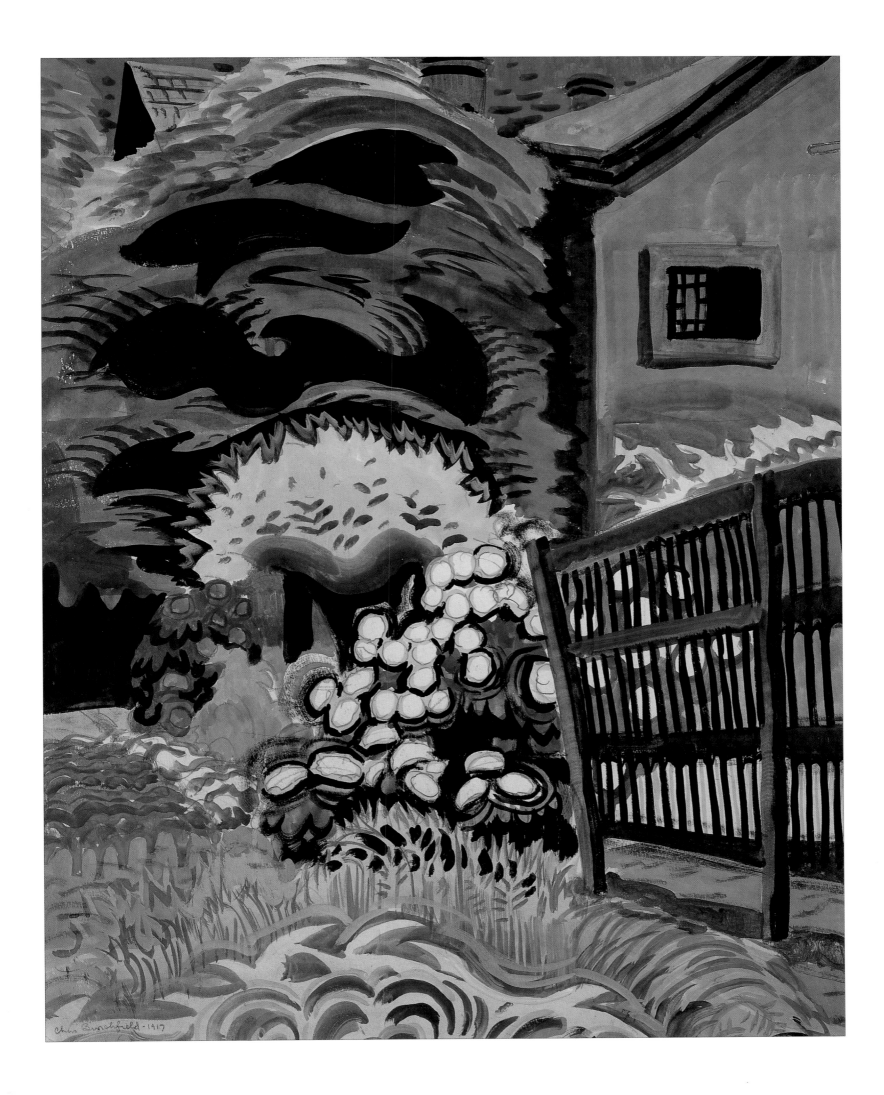

PAUL KLEE

Tree Nursery

1929

OIL ON INCISED GESSO ON CANVAS, 17 1/8" × 20 5/8" (43.5 × 52.4 cm). THE PHILLIPS COLLECTION, WASHINGTON, D.C.

*P*aul Klee (1879–1940), an incredibly prolific (more than nine thousand works) Swiss painter, was also an art the-

orist of great repute, and his paintings reveal profound intellectual concerns. He was also influenced, however, by the

drawings of children, and his work has a sense of true innocence as well. In 1924, Klee made his first "script pictures,"

which consist of different signs inscribed in thin strokes on colored horizontal bands. The script varies from crosses,

stars, and arches to vegetal and anthropomorphic shapes. Under the banner of Surrealism, this method of picture-

making took as its theme the equivalence of writing and painting. In *Tree Nursery*, Klee uses this technique to create a

parceled garden. Although this painting differs dramatically from nineteenth-century garden images, it nevertheless

unmistakably conveys the idea of a garden. Klee's "script pictures" are part of the modern genealogy of invented alpha-

bets by such artists as Henri Michaux, Pablo Picasso, and Joan Miró.

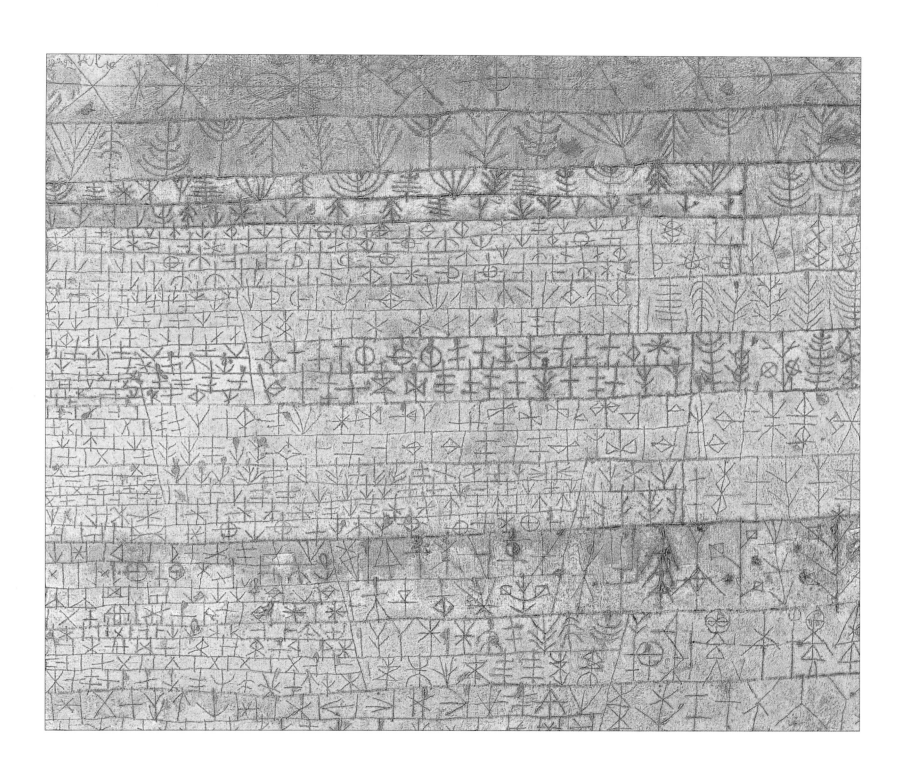

GEORGIA O'KEEFFE

The White Calico Flower

1931

OIL ON CANVAS, 30" × 36" (76.2 × 91.4CM). WHITNEY MUSEUM OF AMERICAN ART, NEW YORK.

The White Calico Flower is among the works most identified with Georgia O'Keeffe (1887–1986), that is, her flower paintings. These magnified blossoms, at once abstract and realistic, are depicted as removed from their natural setting, yet they seem to convey the secret life of nature. Eschewing traditional bouquet arrangements, O'Keeffe chose one bloom and enlarged its proportions to obtain a novel, close-up view. With its myriad folds, the flower invokes associations with the experiences of the body. The effect is intensely sensual, even erotic. Unlike many of O'Keeffe's other flower images, the white flower in this work is based not on organic motifs, but rather on the cloth flowers worn by mourning women in New Mexico as adornments during funeral ceremonies. O'Keeffe, who married Alfred Stieglitz in 1924, lived most of her life in the American Southwest, and drew many of her images from its unique landscape.

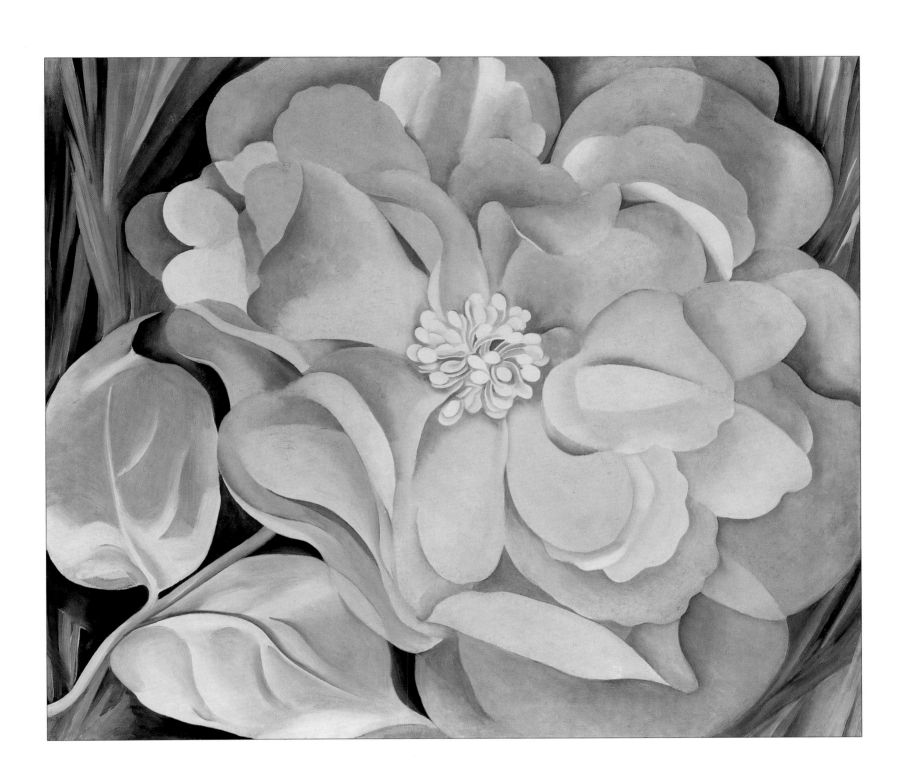

PHOTOGRAPHY CREDITS

Vincent van Gogh, Dutch (1853–1890), *The Garden of the Poets*, 1888, oil on canvas, 28¾" × 36¼" (73 × 92.1cm), Mr. and Mrs. Lewis Larned Coburn Memorial Collection, 1933.433. Photograph © 1994, The Art Institute of Chicago. All Rights Reserved.

Claude Monet (1840–1926), *Women in the Garden*, 1866, oil on canvas, 100½" × 80¾" (255.3 × 205.1cm), Musée d'Orsay, Paris, Erich Lessing/Art Resource, NY

Georgia O'Keeffe (1887–1986), *The White Calico Flower*, 1931, oil on canvas, 30" × 36" (76.2 × 91.4cm), Collection of Whitney Museum of American Art, Purchase, 32.26

Childe Hassam, *Celia Thaxter in Her Garden*, 1892, oil on canvas, 22⅛" × 18⅛" (56.1 × 46cm), National Museum of American Art, Smithsonian Institution, Washington, D.C./Art Resource, NY

Sandro Botticelli, *Primavera*, c. 1482, tempera on panel, 80" × 124" (203.2 × 315cm), Galleria degli Uffizi, Florence, Art Resource, NY

Hieronymus Bosch, *Garden of Delights*, c. 1505–1510, panel painting, 86⅝" × 38¼" (220 × 97.1cm), Museo Nacional del Prado, Madrid, Erich Lessing/Art Resource, NY

Claude Lorrain, French (1600–1682), *Landscape with Nymph and Satyr Dancing*, 1641, oil on canvas, 39¼" × 52⅜" (99.6 × 133cm). The Toledo Museum of Art, Toledo, Ohio; Purchased with funds from the Libbey Endowment, Gift of Edward Drummond Libbey

Antoine Watteau, *Assembly in a Park*, c. 1647, oil on canvas, 12¾" × 18¼" (32.5 × 46.5cm), Musée du Louvre, Giraudon/Art Resource, NY

Hubert Robert, *Interior of a Park with Fountain*, 1770, oil on canvas, 16¾" diameter (42.5cm), Musée de Picardie, Amiens, Giraudon/Art Resource, NY

Jean-Honoré Fragonard, *The Lover Crowned*, 1771–1772, oil on canvas, 124" × 94⅞" (317.8 × 243.2cm), Frick Collection, New York City

Samuel Palmer, *In a Shoreham Garden*, c. 1829, watercolor, 11½" × 8¾" (29.2 × 22.2cm), Victoria and Albert Museum, London/Art Resource, NY

Sir John Everett Millais, *Ophelia*, 1852, oil on canvas, 30" × 40" (76.2 × 101.6cm), Tate Gallery, London/Art Resource, NY

Arthur Hughes, *Aurora Leigh's Dismissal of Romney*, 1860, oil on canvas, 15¼" × 12" (38.1 × 30.5cm), Tate Gallery, London/Art Resource, NY

Gustave Courbet, French (1819–1877), *The Trellis*, 1862, oil on canvas, 43¼" × 53¼" (109.8 × 135.2cm), The Toledo Museum of Art, Toledo, Ohio; Purchased with funds from the Libbey Endowment, Gift of Edward Drummond Libbey

Frederic Edwin Church, *Study of Wild Flowers, Jamaica, West Indies*, 1865, oil on board, 4⁷⁄₁₆" × 6⅞" (11.3 × 17.4cm), Cooper-Hewitt, National Design Museum, Smithsonian Institution/Art Resource, NY, Gift of Louis P. Church, DP1917-4-812

Frederic Bazille, *The Rose Laurels* (also called *The Terrace at Meric*), 1867, oil on canvas, 56" × 98" (142.2 × 248.9cm), Cincinnati Art Museum, Gift of Mark P. Herschede

Pierre-Auguste Renoir (1841–1919), *Monet Working in his Garden in Argenteuil*, 1873, oil on canvas, 18⅜" × 23½" (46.7 × 59.7cm), Wadsworth Atheneum, Hartford; Bequest of Anne Parrish Titzell

Charles-François Daubigny, French (1817–1878), *Fields in the Month of June*, 1874, oil on canvas, 53" × 88" (134.6 × 223.5cm), Herbert F. Johnson Museum of Art, Cornell University, Ithaca, NY; Gift of Louis V. Keeler (Class of 1911) and Mrs. Keeler

Claude Monet (1840–1926), *Gladioli*, c. 1876, oil on canvas, 22" × 32½" (56 × 83cm), The Detroit Institute of Arts, City of Detroit Purchase, 21.71

James Tissot, *The Picnic*, c. 1876, oil on canvas, 30" × 39⅛" (76.2 × 99.3cm), Tate Gallery, London/Art Resource, NY

John Singer Sargent, *Carnation, Lily, Lily, Rose*, 1883–1886, oil on canvas, 68½" × 60½" (171.2 × 151.2cm), Tate Gallery, London/Art Resource, NY

William Merritt Chase, American (1849–1916), *The Open Air Breakfast*, c. 1888, oil on canvas, 37⁷⁄₁₆" × 56¾" (95 × 144.1cm), The Toledo Museum of Art, Toledo, Ohio; Purchased with funds from the Florence Scott Libbey Bequest in Memory of her Father, Maurice A. Scott

Vincent van Gogh, Dutch (1853–1890), *The Orchard*, 1888, oil on canvas, 25¾" × 31⅞" (65.4 × 81cm) Van Gogh Museum, Art Resource, NY

Paul Signac, French (1863–1935), *Places des Lices, Saint-Tropez*, 1893, oil on canvas, 25¾" × 32³⁄₁₆" (65.4 × 81.8cm), The Carnegie Museum of Art, Pittsburgh; Acquired through the generosity of the Sarah Mellon Scaife family, 66.24.2

Gustav Klimt, *Garden with Sunflowers* (also called *The Sunflowers*), c. 1905–1906, oil on canvas, 56" × 98" (142.2 × 248.9cm), Österreichische Galerie, Vienna, Erich Lessing/Art Resource, NY

Henri Matisse, *Joy of Life*, 1905–1906, oil on canvas, 69⅛" × 94⅞" (175.5 × 241cm), photograph © 1995 The Barnes Foundation

Georges Braque (1882–1963), *Olive Trees*, 1907, oil on canvas, 15" × 18³⁄₁₆" (38.1 × 46.2cm), Worcester Art Museum, Worcester, Massachusetts; Gift from the Estate of Mrs. Aldus Chapin Higgins, Worcester, MA

Henri Matisse, *Harmony in Red*, 1908, oil on canvas, 69¾" × 85⅞" (177.1 × 218.1cm), The Hermitage, Leningrad, George Roos/Art Resource, NY/Copyright ARS, NY

Henri Rousseau, *The Dream*, 1910, oil on canvas, 80½" × 117½" (204.4 × 298.4cm), The Museum of Modern Art, New York. Gift of Nelson A. Rockefeller. Photograph © 1994 The Museum of Modern Art, New York.

Marc Chagall, Russian (1887–1985), *Temptation* (also called *Adam and Eve*), 1912, oil on canvas, 63³⁄₁₆" × 44⅞" (160.5 × 114cm), The Saint Louis Art Museum; Gift of Morton D. May

Arthur G. Dove (1880–1946), *Plant Forms*, c. 1912, pastel on canvas, 17¼" × 23⅞" (43.8 × 60.6cm), Collection of Whitney Museum of American Art, New York; Purchase with funds from Mr. and Mrs. Roy R. Neuberger, 51.20

Charles Burchfield (1893–1967), *Noontide in Late May*, 1917, watercolor and gouache on paper, 21⅝" × 17½" (54.9 × 44.5cm), Collection of Whitney Museum of American Art, New York, Purchase, 31.408

Paul Klee, *Tree Nursery*, 1929, oil on incised gesso on canvas, 17⅛" × 20⅝" (43.5 × 52.4cm), The Phillips Collection, Washington, D.C.